THE
Archive Photographs
SERIES

WOLVERHAMPTON GRAMMAR SCHOOL

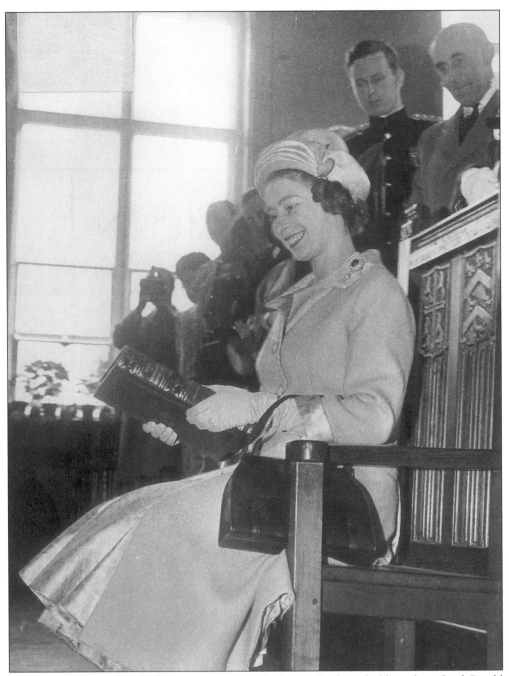

Her Majesty Queen Elizabeth II sitting in the Headmaster's chair, holding the gift of Gerald Mander's *History of Wolverhampton Grammar School* presented to her on the occasion of her visit to the school in 1962.

THE
Archive Photographs
SERIES

WOLVERHAMPTON
GRAMMAR SCHOOL

Compiled by
Deirdre Linton

TEMPUS

First published 2000
Copyright © Deirdre Linton, 2000

Tempus Publishing Limited
The Mill, Brimscombe Port,
Stroud, Gloucestershire, GL5 2QG

ISBN 0 7524 1894 7

Typesetting and origination by
Tempus Publishing Limited
Printed in Great Britain by
Midway Clark Printing, Wiltshire

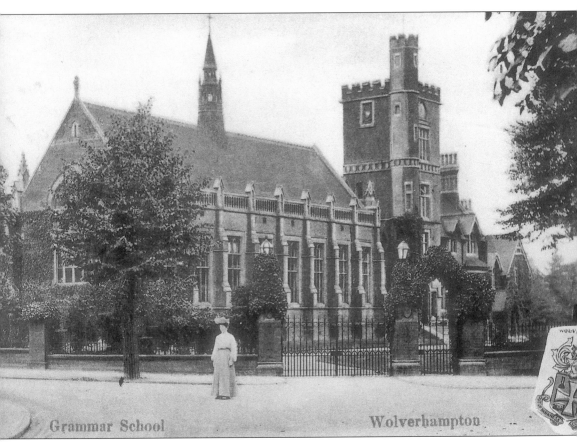

A Victorian postcard of the school.

Contents

Acknowledgements

I am indebted to the Wolverhampton Archive, the *Birmingham Post* and the *Express and Star* (Wolverhampton) for permission to publish photographs from their collections. Also to Bob Andrews, Gordon Dugmore, G.V. Jenkins, Chris Jones, D. Nightingale and Lesley Peat for permission to use photographs taken by them of school events.

Gerald Mander's *History of Wolverhampton Grammar School* of 1911 was an important source for the early history of the school.

The following people have been generous with their gifts or loans of photographs, or with their time given to checking of faces and detail and I thank them all. If there are errors or omissions in the many lists of names, including this one, I apologize.

Mrs Jann Acton, Mr J.S. Anderson, Mr B. Banson, Mr M. Brayshaw, Mr D. Bourne, Mr P. Bourne, Miss C. Brough, The Burnett family, Mr D.J. Coast, Dr and Mrs J. Darby, Mr J. Derry, Mr H.G. Fidler, Mr M. Foreman, Mr B. George, Mr R. Hooper, Mr D. Hughes, Mr P. Hutton, Mr Latham, Mr T. Lawrence, Mr J.G. Lewis, Mr H. Palmer, Mr B. Polack, Mr W.C. Rees, Mr G. Richards, Mrs M. Roper, Mr E. Sergeant, Mr T. Sharp, Mrs V. Simkin, Mr A. Stocks, Miss F. Stoy, Mr H. Till, Mr K. Woodward and Judge M. Ward, whose patience and encyclopaedic knowledge of the school have proved especially valuable.

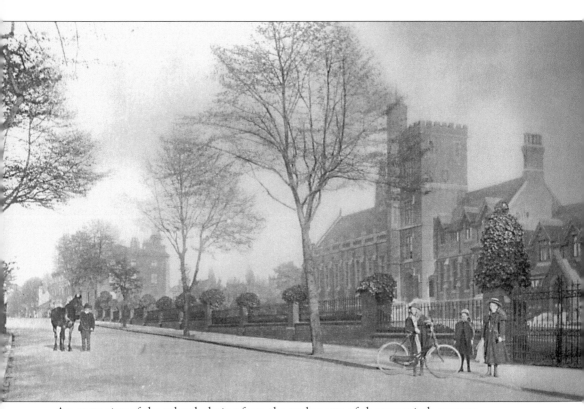

An engraving of the school, dating from the early years of the twentieth century.

A Brief History of the School

Although there may have been an earlier school attached to St Peter's Collegiate Church, the earliest evidence for the existence of the Grammar School at Wolverhampton lies in the letters patent describing the endowment of the school in 1512. The founder was Sir Stephen Jenyns, who was born in Wolverhampton but became a wealthy merchant and Lord Mayor of London in the reign of Henry VIII. He was a highly successful member of the Merchant Taylors' Company and it was the accepted practice of the time for such men to use their good fortune to provide for their home towns in some way. So it was that he chose to found a school at Wolverhampton.

The original school was not on its present site but on the southernmost edge of the town, among fields and gardens close to the main Worcester road, on what became known as St John's Street. It seems likely that the land and buildings already belonged to the Jenyns family when the school was endowed.

Sir Stephen gave the Manor of Rushock, in a parish between Kidderminster and Worcester, to the Merchant Taylors', to provide the income for them to maintain the buildings and pay for two masters, the headmaster and his assistant, who was called the usher. As far as is known, this was the only school to be maintained by the Merchant Taylors' Company before the Reformation. According to the letters patent the Merchant Taylors were to oversee the school 'for the instruction of boys in good morals and learning'. Learning at this time meant Latin and Greek, which were essential then for all those wanting to advance themselves.

The school was a small one for most of its time at St John's Street, its success entirely depending on the quality of the two masters at any time. The balcony erected on behalf of the Merchant Taylors in St Peter's church, Wolverhampton, for the benefit of the school in 1611 holds between sixty and seventy schoolchildren. It was intended to seat the entire school. In 1772, when the Headmaster, Dr Robertson, was old and the school in disrepair, the numbers fell to five boarders and 'less than thirty' day boys.

The Merchant Taylors governed the school well for over two hundred years but the standards of this administration had declined by 1766, when the town petitioned for a review. As a result the Merchant Taylors' Company ceased to have responsibility for the school in 1784, when it was transferred to a local trust. When the new trustees were appointed, they both repaired and expanded the school, so that by 1844 the number of students had reached 120. However, numbers soon started to decline again as discontent increased among the townspeople of Wolverhampton about the cramped school buildings and their situation in what had grown to be a heavily polluted industrial area. Another bone of contention was the way in which the school had started to take boarders to make money, increasing their numbers at the expense of places for local children. Wolverhampton's businessmen were also aware of the move to teaching a wider curriculum taking place in other schools.

A new form of charitable trust was set up in 1854 which gave local students priority so that it again became predominantly a day school, although the last boarder only left in 1941. Under Mr Campbell, Headmaster from 1855 to 1863, mathematics, languages, drawing and music were added to the curriculum. This proved popular and numbers increased until parents realized there was no money for the extra teachers needed to teach the new subjects.

Campbell urged the Trustees to be ambitious, to move to a large site and expand the whole enterprise but, finding them too hesitant and resistant to change, he resigned. The school shrank again to just forty-four boys. This concentrated the minds of the Trustees, who set up a new system providing for an 'English' education as well as a Classical one and enabling more teachers to be paid for. They then appointed two remarkable masters – Mr Beach as Headmaster

and Mr Williams as Usher – who made such a mark in both the school and the town that by 1867 there were 187 boys and others had to be turned away. This was the final proof Thomas Beach needed to establish that the school had, indeed, outgrown its old, dilapidated premises. In 1869 the Trustees agreed to purchase land and build a new school.

In 1875 the school moved to its present site on Compton Road with 223 boys – a sevenfold increase in twenty years. The school grew in prestige as its university successes were publicized, and its new open-field site enabled the school to gain a sporting reputation. Informal links with the Merchant Taylors' Company were renewed – and remain to this day.

Following the 1902 Education Act the school obtained rate support from Wolverhampton to maintain standards. It battled to keep some form of independence from the Local Education Authority for the next seventy years, becoming a direct grant school in 1908 and a voluntary aided school in 1949. Under the strong leadership of Mr Warren Derry, Headmaster from 1929 until 1956, the school became one of the most successful grammar schools in the country. His successor, Mr Ernest Taylor, did much to keep the school at the top and he presided over an extensive building programme, made possible by the financial help of parents and old boys.

By 1967, however, the first signs of difficult times ahead were clear as the Local Education Authority started to consider how to introduce comprehensive education into the town. Mr Taylor retired in 1973 and it was his successor Mr Tony Stocks, returning to the school where he had taught so successfully from 1947 to 1957, who bore the brunt of the long battle to retain the school's character in the face of change. In 1977 the negotiations ended. The LEA informed the school that they would send no pupils to the school in 1978. Independence became the only option. A marathon fund-raising campaign was launched so successfully that, recognizing the overwhelming determination of Headmaster, Governors and parents alike, the LEA gave a reprieve of one year. Independence secured, Mr Stocks took well-earned retirement in 1978.

In September 1979, Mr Patrick Hutton, the new Headmaster, welcomed the first fee-paying pupils for forty years into the first form. Thanks to his leadership, and the strength of the governing body, the transfer to independence was a success. Furthermore, the introduction of the Assisted Places Scheme meant that poorer pupils were again able to receive financial help to attend the school, now directly from the government. Its traditional role in Wolverhampton restored, the school flourished.

The school remained a boys' school until 1984 when girls were allowed to join the sixth form. The present Headmaster, Dr Bernard Trafford, oversaw the introduction of girls into the first form in 1992. With the increase in government support through the Assisted Places Scheme, the school was able to expand and undertake a substantial building programme. The abolition of the scheme by the incoming Labour government in 1997 returned the school to the complete independence from state support it last knew before 1902.

The school immediately launched the *Sharing the Vision* Appeal to fund as many scholarships as possible, to ensure that the school would continue to serve the local population by offering the school's particular style of education to all those who would welcome the opportunity to enjoy it. The proceeds from this book will be used to provide such scholarships.

One

St John's Street
1512-1875

No one knows what the original building looked like, though it was probably a half-timbered structure like other local buildings of the time. The school consisted of three elements – the school room with two houses, one at each end, for the Headmaster and his assistant, who was called the Usher. These buildings became dilapidated and were rebuilt between 1712 and 1717, but the ground plan remained the same. After a further refurbishment, and the addition of a second classroom behind the Usher's house in 1785, there were no further changes to the buildings. Gradually they became surrounded by 'japan manufactories and chemical works', so that the air was unpleasant to breathe. Unable to expand, the school was forced to move to new premises. The buildings were sold off and became commercial premises. They existed until 1964 when they were demolished to make way for the Mander Centre.

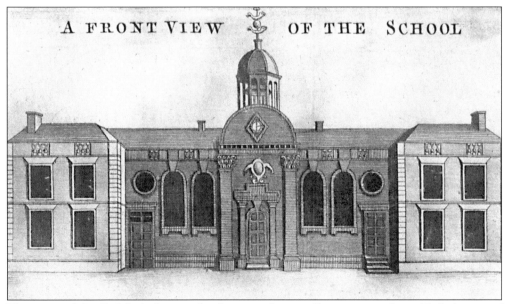

This view of the St John's Street school appeared as an illustration on Isaac Taylor's map of Wolverhampton of 1750. It is the earliest known picture of the school.

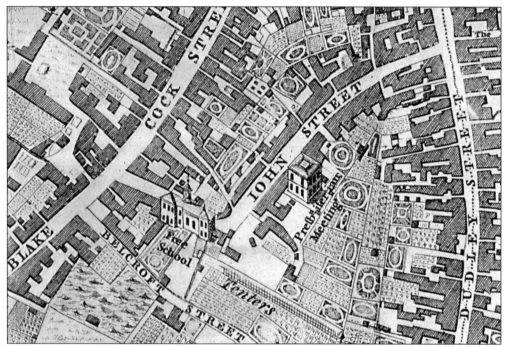

The position of the school on the edge of the town is clear from this detail from Taylor's map. It also shows that, while the Headmaster has a formal garden, the Usher has a plain allotment. The road is here labelled John Street while at other times it was known as John's Lane.

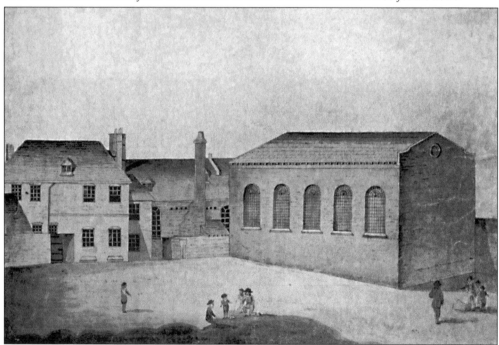

Taken from an original pen and water-colour drawing of 1795, this view shows schoolboys playing at the back of the school. There is no longer a formal garden; this was removed in 1785 when the playground was extended.

This portrait of Dr William Robertson, Headmaster from 1768 to 1783, appeared in *The Gentleman's Magazine* in 1783. In 1772 he exchanged the old bell 'which had become quite worthless' for a new clock and had the bell turret removed. A smaller bell survived to be brought to the present school, where it hangs behind Big School.

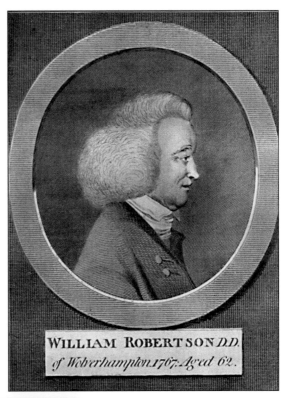

WILLIAM ROBERTSON *D.D.* *of Wolverhampton 1767. Aged 62.*

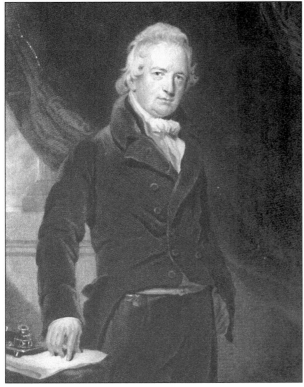

A pupil at St John's Street from 1773 to 1778, John Abernethy autographed this picture for his old Headmaster. He was a famous anatomist and founded St Bart's Medical School.

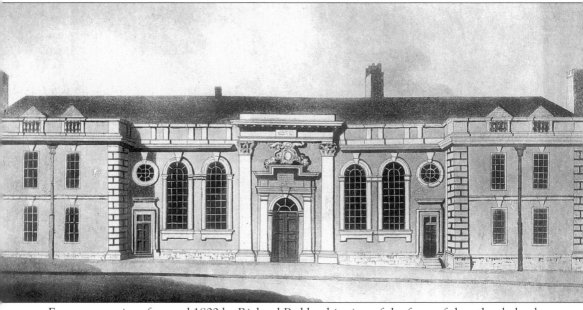

From a rare print of around 1800 by Richard Paddy, this view of the front of the school clearly shows the engraved stone over the door marking the rebuilding of the school in 1713. This stone was removed in 1875 and taken to the new school in Compton Road.

Schola Publica Grammaticalis
Pueris pietate, bonis moribus ac literis instituendis sacra,
a STEPHANO JENYNS Milite, Cive ac Aldermanno Londinensi
Anⁿ. Domⁱ. MDXV°.
fundata et dotata;
Societatis verò Mercatorum Scissorum Londini, cujus Socius erat,
Fidei commissa.
Postquam autem ex vetustate pæne collapsura esset
ab eâdem Societate, Anⁿ. Domⁱ. MDCCXIII°.
Instaurata atque amplificata.
ROGER ATLEE Master
JOHN HARRIS} JAMES BALL
THOMAS HARRIS} Major THOMAS PITTS } Wardens

The stone is now set high in the wall of Big School on the side opposite the windows and is familiar to every generation of students.

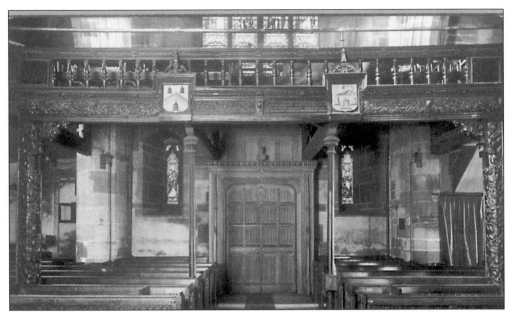

Another survival from the time of the St John's Street school is the gallery under the west window of St Peter's church, which was built in 1610 to seat the whole school. It seats sixty schoolchildren. This postcard dates from the 1920s.

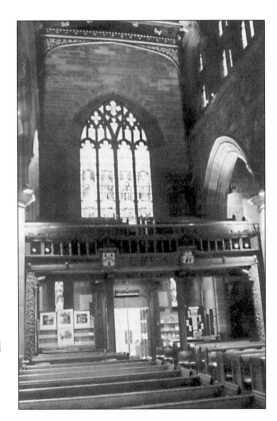

The balcony as it looked in 1999. It is still used on Founder's Day, although the school now fills the entire church. The coats of arms are those of Sir Stephen Jenyns to the left, and the Merchant Taylors' Company to the right.

The Revd Thomas Campbell was a remarkable Headmaster with liberal views, who wanted more provision for the poor boys of the town. Frustrated in his efforts to modernize the school by introducing science, he resigned in 1863 and sailed to New Zealand to take up the post of Headmaster of Dunedin School. Tragically, the boat sank off Otago and he and his family were drowned.

Dating from 1871, not long before the move to Compton Road, this is the earliest photograph of the St John's Street school to survive.

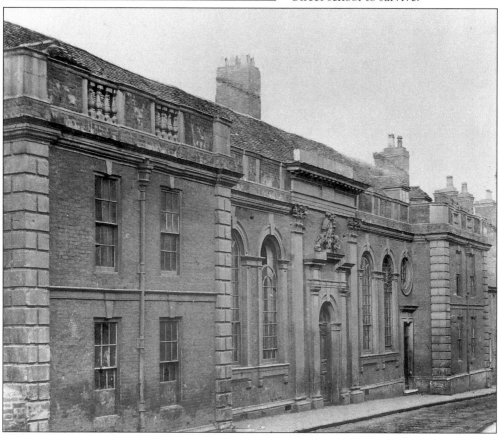

The report of Herbert Hipkins for Christmas 1873, when the school was still at St John's Street. This is the name given to the road in school documents by this time.

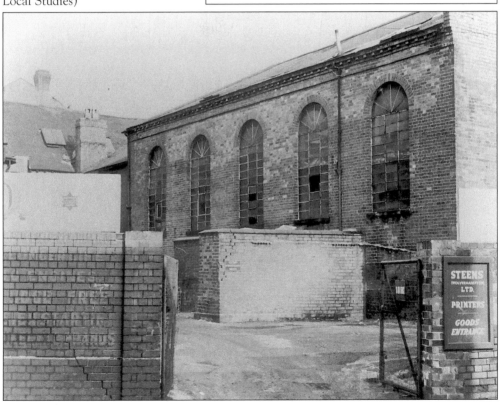

WOLVERHAMPTON GRAMMAR SCHOOL.

QUARTERLY REPORT, 1873 *Christmas*

HERBERT
Hipkins

	1st Week.	2nd.	3rd.	4th.	5th.	6th.	7th.	8th.	9th.	10th.	11th.
Place in *F D* Form of *24* Boys.	3	13	3	7	7	2	1	1	1	2	

Master of the Form's Report. *Very satisfactory. He never fails to do his work really well W. H. Hooper M. A.*

Mathematics. *Very fairly improved L. H. H.*

Writing and Arithmetic. *Very good progress this quarter in Writing and Arithmetic. History, Geology and Geography*

French. *Very Good, Hipkis has done well done his during the quarter. W. V. Smith.*

German.

Drawing.

General Conduct. *Good L. H. H.*

PLACE IN CHRISTMAS EXAMINATION.

	Latin.	Greek.	Algebra.	Euclid	Arith-metic.	Greek Testament	Scripture History.	General History.	Geography	English Grammar and Composition	French.	German.
Number of Boys examined.	17	16	26	26	28		7	17	17	17	19	
Place.	1	1	15	4	12		2	10	6	1	4	

Examined and approved,

R. Beach M. A. HEAD MASTER.

The School will re-open on *Feb 3rd* 1874

In 1964 local historians recorded in detail the area to be cleared for a new shopping centre. The hall at the back of the St John's Street school housed a printers' workshop. (From the collection of Wolverhampton Archive and Local Studies)

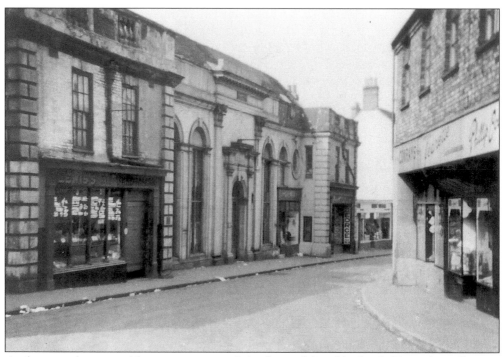

At the same date several businesses occupied the front of the old school. (From the collection of Wolverhampton Archive and Local Studies)

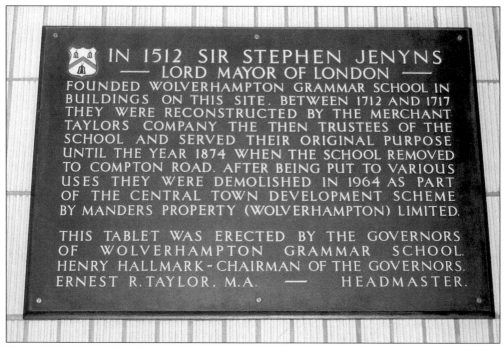

IN 1512 SIR STEPHEN JENYNS
—— LORD MAYOR OF LONDON ——
FOUNDED WOLVERHAMPTON GRAMMAR SCHOOL IN BUILDINGS ON THIS SITE. BETWEEN 1712 AND 1717 THEY WERE RECONSTRUCTED BY THE MERCHANT TAYLORS COMPANY THE THEN TRUSTEES OF THE SCHOOL AND SERVED THEIR ORIGINAL PURPOSE UNTIL THE YEAR 1874 WHEN THE SCHOOL REMOVED TO COMPTON ROAD. AFTER BEING PUT TO VARIOUS USES THEY WERE DEMOLISHED IN 1964 AS PART OF THE CENTRAL TOWN DEVELOPMENT SCHEME BY MANDERS PROPERTY (WOLVERHAMPTON) LIMITED.

THIS TABLET WAS ERECTED BY THE GOVERNORS OF WOLVERHAMPTON GRAMMAR SCHOOL. HENRY HALLMARK - CHAIRMAN OF THE GOVERNORS. ERNEST R. TAYLOR. M.A. —— HEADMASTER.

This plaque on a wall in the Mander Centre marks the site where the original school stood.

Two

Compton Road
1875-1902

After a long campaign on the part of the Headmaster, Thomas Beach, and the Chairman of Governors, Sir Rupert Kettle, the school purchased sufficient land to build a new school building, a house for the Headmaster and provide five acres of land for sport. The site chosen was part of Merridale Farm, which then lay outside the town. The cost was met by a combination of mortgaging part of the Rushock Estate, selling the old school, and a very successful public subscription. The foundation stone was laid on 10 April 1874 and the building was first occupied on 15 October 1875. After twenty years these facilities were themselves becoming inadequate, and another subscription led to the construction of the first science building, which was opened in 1897.

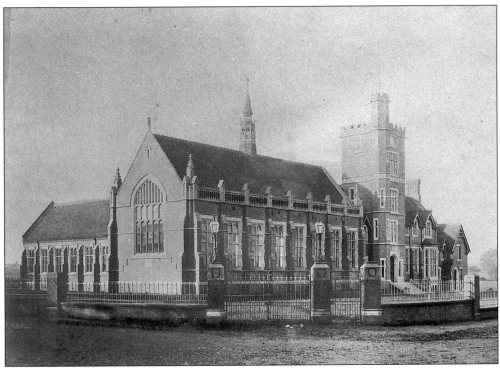

The newly built school standing in fields outside the town. (From the collection of Wolverhampton Archive and Local Studies)

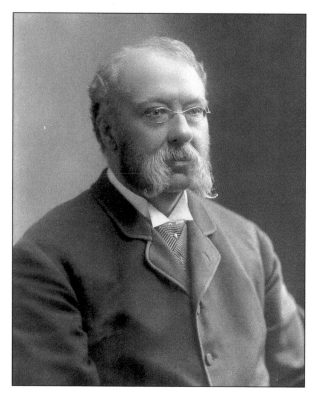

Thomas Beach was an extraordinary man of immense dedication and forthrightness, so much larger than life that he was a force to be reckoned with in both school and town. A conservative teacher of the old classical style, his scorn of science was so intense that when the governors appointed the first science master in 1889, he resigned.

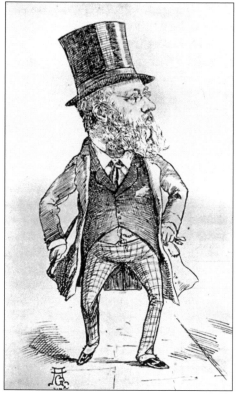

This caricature of Beach appeared in *The Magpie* on 28 February 1885. His appearance was striking, his head unusually large for his body, his face very red and his hair and whiskers always coloured 'by no natural phenomenon'. He invariably wore check trousers and a very large diamond ring, which was 'always to be seen and frequently felt.'

The first prospectus for the new school, issued in 1875, praised the healthy country atmosphere of the new site.

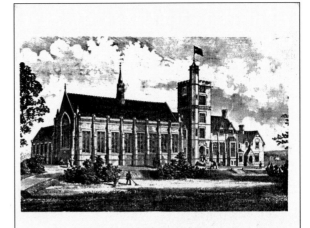

WOLVERHAMPTON SCHOOL.

FOUNDED A.D. 1515

This ancient Grammar School is, under the new scheme issued by the Endowed Schools Commissioners, a First-grade Public School.

The Course of Education embraces Greek, Latin, Mathematics, Natural Science, Modern Languages, Bookkeeping, Arithmetic, and general English Subjects.

The School is officered by a large and efficient Staff of Masters, comprising Graduates of high Standing of the Universities of Oxford and Cambridge ; and also Graduates of Paris and Berlin as Teachers of Modern Languages.

The School is situated in the western suburb of the town, in a locality distinctly separated from the manufacturing district, and in the midst of beautiful rural scenery.

In the 1870s the parts of the school were, from the left, the schoolroom, or Great Hall as it was then called, the entrance tower for boarding accommodation, the boarders' dining room, and the Headmaster's house.

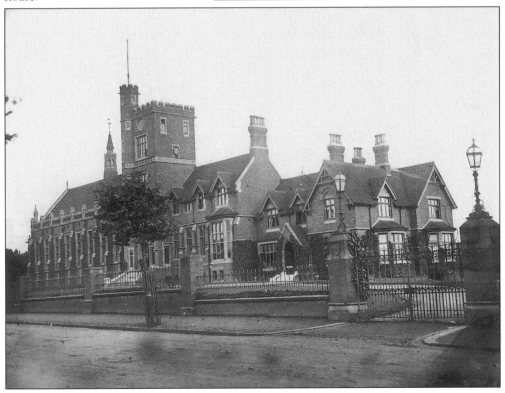

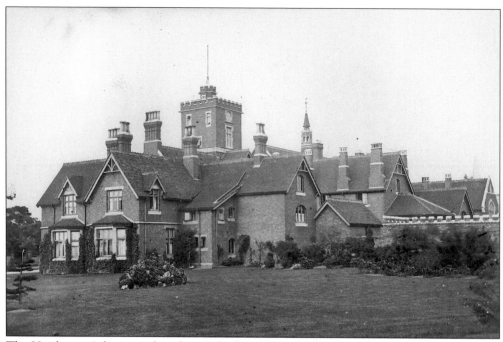

The Headmaster's house and garden in the late 1880s. In the foreground is the fence marking the school boundary at that time. (From the collection of Wolverhampton Archive and Local Studies)

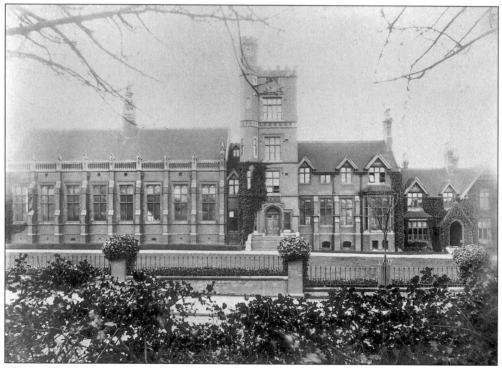

The front of the school at the same date, also from the collection of Wolverhampton Archive and Local Studies.

Moreton's Piece is a strip of land along Merridale Lane given to the school in 1873 by John Moreton. In this photograph, which pre-dates the construction of the science building in 1897, it is grazed by sheep. The house which was to be bought in 1911 can be seen to the left.

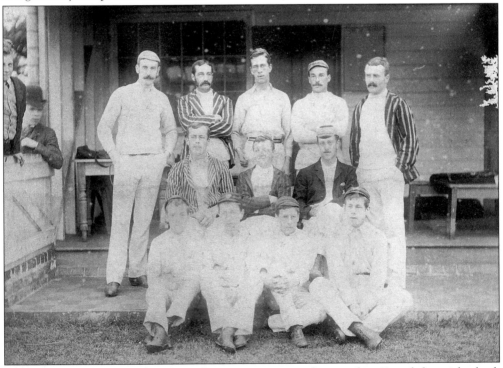

In 1890 boys and masters played together in important cricket matches. From left to right, back row: Mr Wheater, Mr Rowland, H. Hodges, T. Ward, Mr Clodd. Middle row: M. Slater, G. Crane (Captain), Mr Robinson. Front row: -?-, -?-, -?-, A. Wolverson. The boy standing on the far left was the scorer.

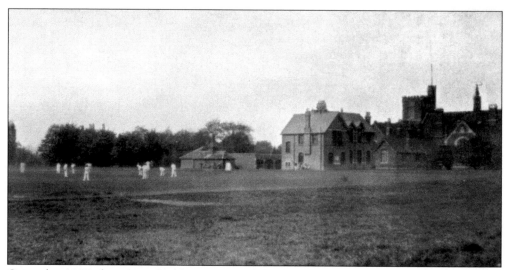

Opened in 1897, the science building contained the school's first laboratories. Only physics and chemistry were taught; biology was not introduced until 1957.

The newly opened science building can be seen through the spectators in this snapshot of the 1897 Sports Day.

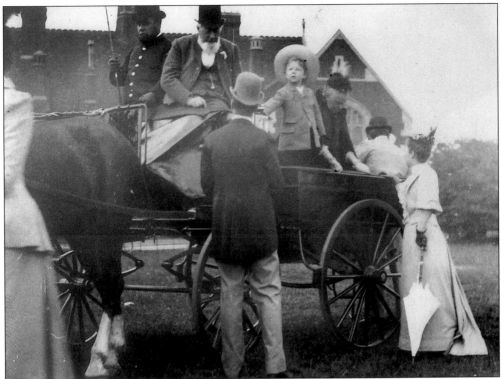

Sir Rupert Kettle was the outstanding Chairman of Governors and benefactor who supported Mr Beach in his campaign to move from John Street. His coat of arms can be seen in the stained glass window in Big School. Here, with white beard, he leaves his carriage as he arrives for the 1897 Sports Day.

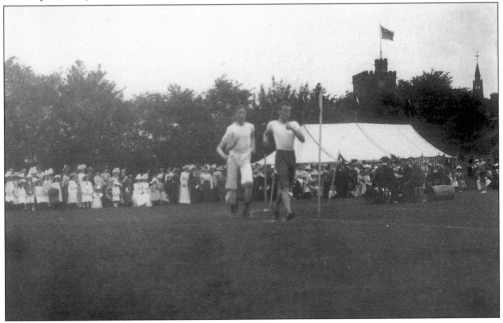

Competitors running the mile on the same occasion.

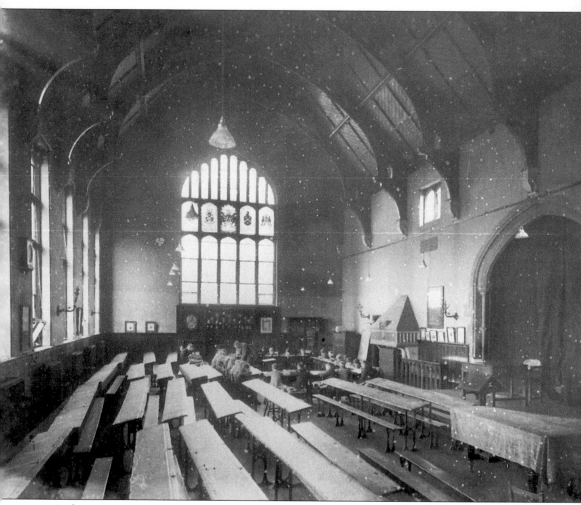

A class in progress in Big School, or the Great Hall as it was originally called. This was the main teaching area, with several groups of desks and benches for different forms. The archway on the right, where the organ now stands, was the focal point of the hall in its early days. (From the collection of Wolverhampton Archive and Local Studies)

Three
The Direct Grant School
1902-1928

After constructing the science building, the school found that it was still short of classrooms, but had no money to build any. Furthermore, it was unlikely that more funds could be raised by the school alone so soon after the last appeal. The Headmaster, Mr Hitchin, asked the town for funds but the town wanted control of the school in exchange, to which he would not agree. When Mr Watson Caldecott became Headmaster in 1905, the number of pupils had fallen to 160 and the school was running at a loss. However, the setting up of Local Education Authorities by the government in 1902 led to the possibility of annual direct grants to the school, in exchange for free places for local elementary boys. In 1907 twenty-five boys 'likely to be a credit to the town and school' took up free places at the school in exchange for a grant to the school of £300. As a result new buildings and facilities were opened in 1908 and numbers steadily rose, reaching 560 in 1923. Although the use of local money to support an otherwise independent school did not go unopposed, the school received an annual direct grant until after the Second World War.

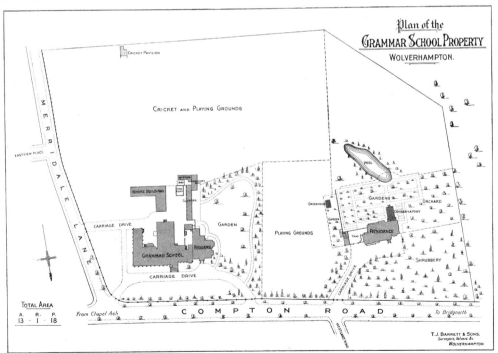

This plan of the school must date to 1909/10. The science building was extended and the Rugby fives court built in 1908. The building labelled 'Residence' became the Junior School in 1911.

Mr Watson Caldecott was a brilliant sportsman as well as a first-rate academic. A strict but tactful man, he always wore a black silk hat and tails – except when he went to watch the Wolves, when he wore brown tails instead. It was he who founded the Junior School.

Mr Alfred Robinson, classics master at the school from 1890 till 1928 and Second Master from 1896, was the author of the school song *Carmen Wulfrunense*. He was also a keen amateur photographer.

Mr Fuoss, 'Fuzzy' to the boys, was a German refugee who taught languages at the school from 1892 to 1927. He was a strict but kindly man, who was much liked. His son fought for Britain in the First World War.

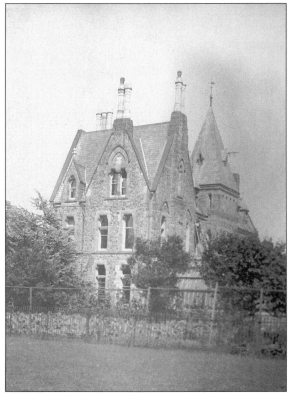

Built by Mr Selwood Riddle in 1879, 'Riddles' was bought by the school and converted into a Junior School for boys of eight to ten years of age in 1911. In 1913 the Remove, as the first form was known, also moved there 'from the platform end of Big School'.

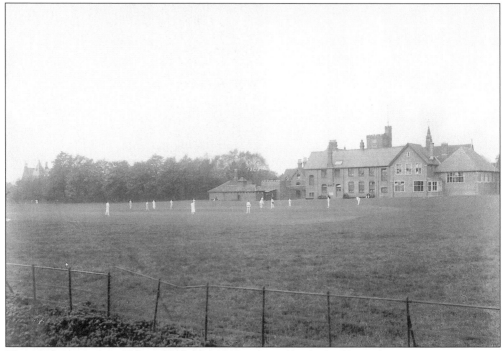

The 400th anniversary of the school was commemorated by the building of a new gymnasium, seen here on the far right. Opened in 1915, it adjoins the science building extension of 1908.

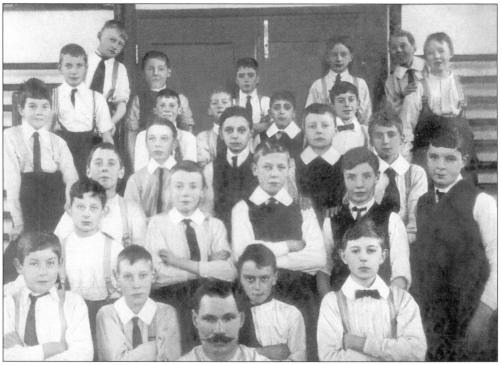

Class 3B are pictured inside the gym in 1916 with their PE instructor, Sergeant-Major W.F. Blakeley, at the front. Second from the right on the third row back is Stanley Brookes.

At the age of fourteen, William Coast joined the Officers' Training Corps when it was founded by Mr Wyatt-Edgell in 1911. In the First World War he served in the Royal Army Medical Corps and returned to teach in Wolverhampton for many years.

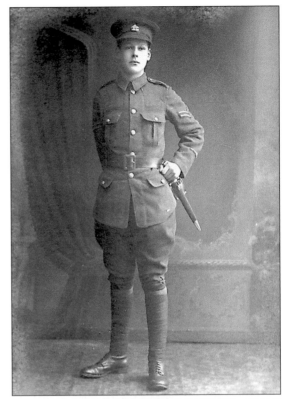

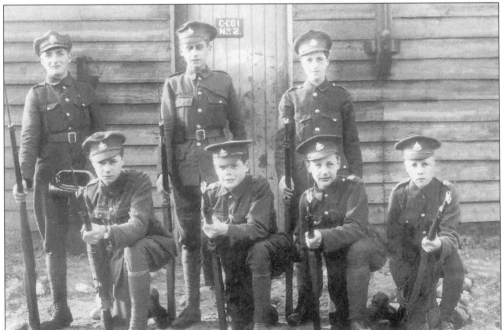

The OTC became an important part of school life during the war years and beyond. Taken at Brocton Camp in 1917, this photograph includes Stanley Brookes at bottom right with Norman Brook, the future Lord Normanbrook, on his left.

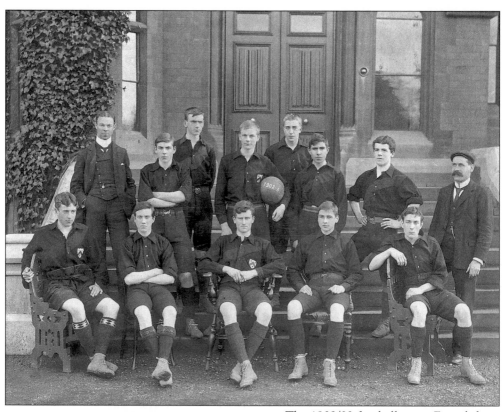

The 1902/03 football team. From left to right, back row: Mr ?, J.H. Furnival, N.J. Hodkinson. Middle row: F.H. Gibbons, W.R. Lucas (captain), W.A.R. Wilkes, H. Yeatman, Mr H. Rumsey. Front row: C.E. Tipton, J. Killin, R.C. Willcock, N.A. Boswell, F.J. Gylby. Eight became officers in the war and survived.

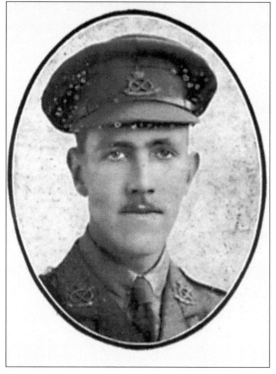

Corporal Robert Willcock refused a commission, preferring to stay with his 'pals'. He died with them at Delville Wood on the Somme on 23 July 1916, aged thirty.

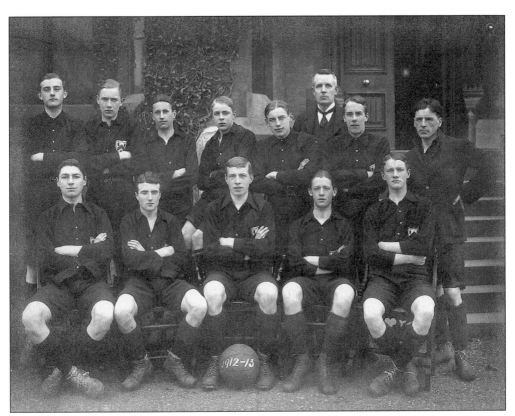

All of the team of 1912/13 fought in the war – two died, two were disabled. Mr Caldecott stands behind. From left to right, back row: G. Onions, G.L. Wood, B.H. Cope, H.H. Mould, P. Dumbell, C. Hurdman. Front row: J.H.C. Luce, G. Murphy, J. Ryan, C.B. Law, R.C. Lockley.

Having won a scholarship to Cambridge, Cyril Hurdman was sent to the Western Front. He was killed when he was ordered 'over the top' in 1916. He was twenty years old.

The War Memorial Screen, inscribed with the names of 102 old boys who died in the First World War, was unveiled on 1 February 1922.

D. W. Armitage.	P. E. Edkins.	R. Lewis.	H. Summers.
F. R. Armitage, d.s.o.	E. W. Edwards.	E. Littlehales.	J. R. Swallow.
J. Barker.	A. S. Fellows.	N. Lloyd-Parton.	A. E. Sweeting.
W. R. Barnett.	K. R. Furniss.	J. A. Lovatt.	J. M. Tatton.
J. N. Beach.	C. J. Gandy, m.c.	N. R. Lowder.	R. Thom.
A. Beal.	M. H. Goodyear.	W. N. Lowe.	G. S. Thorne.
A. Œ. Bendall.	H. S. L. Griffiths.	F. L. Malet.	H. U. H. Thorne
A. C. V. Bigwood.	J. K. Groves.	W. S. Mathie.	G. P. Underwood
P. G. Birch.	W. N. Groves.	A. W. S. Molineaux.	T. A. Voyce.
C. G. Boswell.	H. G. Hall.	A. W. Moore.	J. J. Walker.
S. M. Butler.	O. A. Hall.	P. J. Morgan.	H. Walters.
S. Castle.	S. C. Harris.	J. L. M. Morton.	J. Walters.
J. R. Caswell, m.m.	T. E. C. Haworth.	H. G. Mould.	F. M. Walton.
T. Cheadle.	T. T. Heath.	G. Murphy.	A. F. Warner.
E. C. Christian.	B. V. B. Hewitson.	W. H. Nokes.	D. S. Webb.
L. B. Cole.	J. A. Hinton.	R. Page.	E. A. West.
T. L. V. Colley.	L. A. Hoole.	R. P. Phipps.	W. H. Wheatcroft
W. N. Court.	R. H. Hoole.	H. Piper.	H. Whitehouse.
V. Craddock.	G. L. Howell.	E. G. Rice.	N. B. Wilkes.
V. J. E. Craddock.	F. H. W. Hunt.	N. J. Robinson.	G. B. Wilkinson.
E. A. Cresswell.	S. A. Hunt.	L. G. Shaw.	F. N. Willcock.
A. M. Cullwick.	C. Hurdman.	F. P. Silvers, m.c.	R. C. Willcock.
K. Davies.	B. C. K. Job.	C. E. Sims.	A. Winter.
R. H. Down.	E. Jones.	L. A. Sims.	J. F. Yeatman.
A. L. Duddell.	H. M. Kendrick.	L. Smith.	
E. Ecclestone.	L. Lawson.	S. P. Smith.	

The list of names of those who died from the service sheet of the 1922 dedication ceremony.

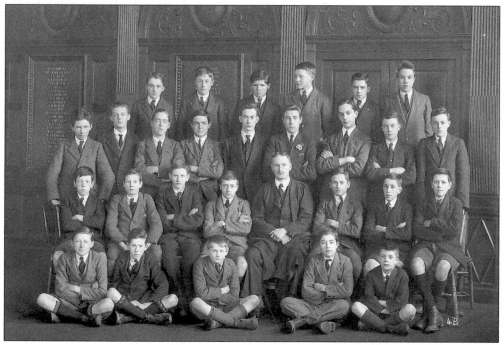

Class 4B in front of the newly erected memorial. Fourth from the left on the third row back is Dennis Moore, whose father's name is inscribed on the memorial behind him.

A.W. Moore, Dennis's father, was the last Old Wulfrunian to die on active service in the First World War. He died on 28 October 1918. Adele Burnett, a student at the school from 1993 to 2000, is a direct descendant of the Moores.

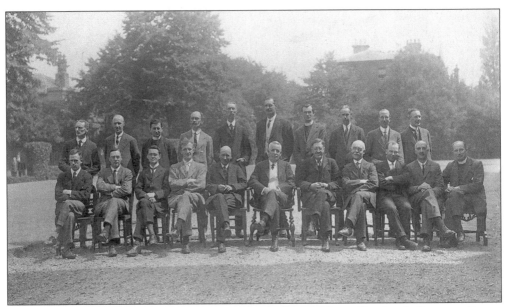

The teaching staff in July 1921. From left to right, back row: Messrs Handcock, Dunnett, Evans, Walker, Blow, Lloyd, Crump, Harding, Sheldon, Harper. Front row: Messrs Hodgetts, Dance, Williams, Buckley, Crickmay, Caldecott, Robinson, Fuoss, Carhart, Wyatt-Edgell, Bentley.

This photograph of the OTC was taken in 1921 at the Strensall Camp. Major Wyatt-Edgell, the OTC commander, is the officer seated to the left of centre. A chemistry master, he taught at the school from 1910 to 1945.

The cricketers of 1921 were outstanding. With Mr Hodgetts, Mr Robinson and Mr Caldecott are, from left to right, back row: O.N. Jones, E.S. Stoy, L.A. Jones, Stone, Ruston, Holder. Front row: Whicker, Bendall, Norman Brook (captain), Lloyd, Jervis. They beat the Masters by 7 wickets and 38 runs.

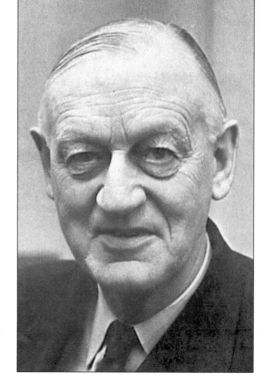

An outstanding scholar and sportsman at the school, Norman Brook had a brilliant career as Secretary to the Cabinet from 1947 to 1962. He was created Baron Normanbrook of Chelsea in 1963 and was Director General of the BBC from 1964 until his death in 1967.

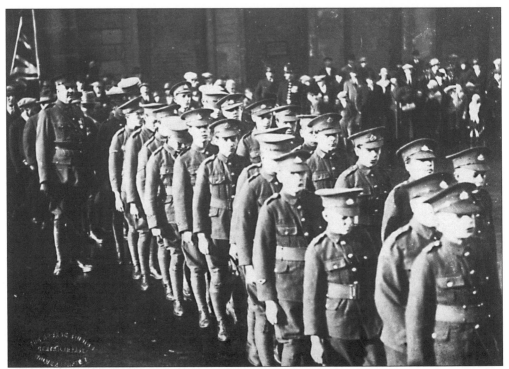

The OTC taking part in the Mayor's parade in Wolverhampton in the 1920s. On the left at the back the tall figure is Mr J.B. Harding, who commanded the OTC for many years.

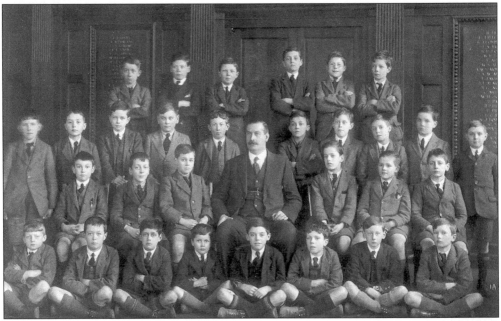

Mr Lloyd was form master of 1A in 1922. From left to right, back row: Fowler, Crawford, Dumbell, Ingham, Warboys, Pedley. Second row: Milner, Bangham, Heeley, Goodall, Golcher, Sambrook, -?-, Marlow, -?-, Howarth. Third row: Bussey, Bowdler (?), Tomkinson, -?-, Law, Haynes. Front row: Whitehead, Plant, Postans, Stanbury, Middleweek, Armer, Jackson, Brown.

Young and dynamic, Mr W.R. Booth, Headmaster from 1923 to 1928, was a strong disciplinarian but firmly believed that rewards were as necessary as punishments.

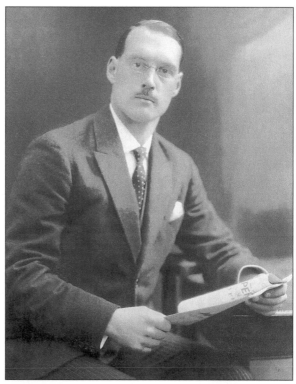

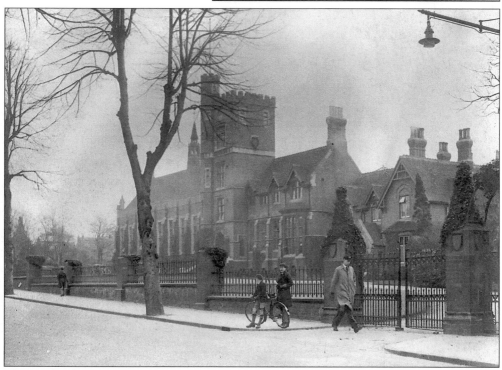

These schoolboys, at the school gate on Compton Road, are wearing the school caps, or Founder's caps, introduced as an award for merit by Mr Booth.

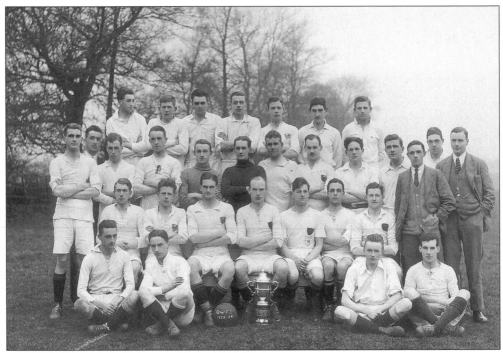

The Old Wulfrunian Football Club was founded in the year this photograph was taken. They fielded two high-quality teams, one of which beat the school's First XI 6-0.

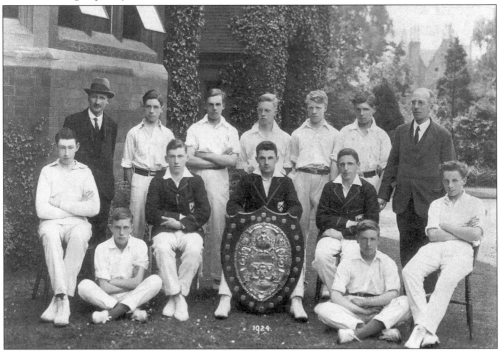

The house system was founded in 1898, with five houses – North, South, East, West and School House (the boarding house). Mr Crickmay, on the left, and Mr Sheldon, on the right, here flank the East House team with the House Cricket Shield in 1924.

Prefects were first introduced in 1897 but had no powers until the system was reformed by Mr Booth. The prefects of 1926, seen here, included R.H. Stoy, one of the four brothers after whom the Stoy awards are named.

Professor Richard Hugh Stoy had a brilliant academic career. He was Her Majesty's Astronomer at the Cape from 1950 until 1968 and he died in 1994. Remarkably his brother Philip was also a professor – of dentistry.

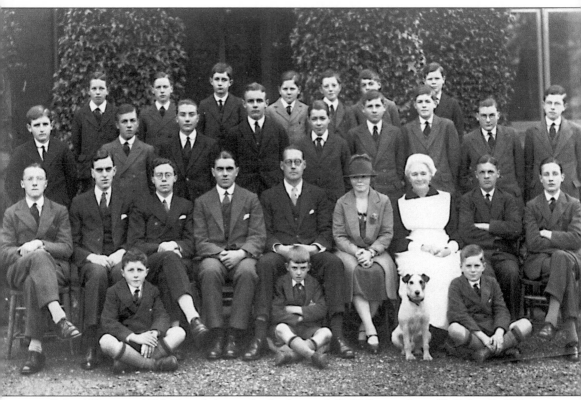

School House in 1927. From left to right, back row: L.K. Williams, Gray, H. Dyke, R. Wilson, Pountrey, Walley, J.M. Wilson. Second row: J. Dyke, L.A. Williams, Bangham, Deller, Margary, Johnson, Little, Baker, Heeley. Seated: Bellhouse, Mr Lax, Mr Duffield, Mr Booth, Mrs Venables, the matron, Kimberley or 'Kim', the housekeeper, Eden, N.Benson. Front row: Craddock, Davies, Nibs the dog, Dainty.

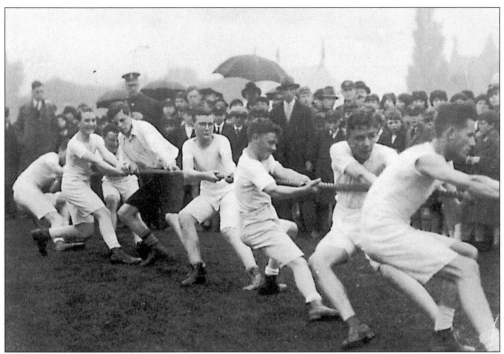

The School House team in the tug of war at the 1927 Sports Day. From left to right: Ward, Bellhouse, Bangham, De Wys, Baker, Eden, Deller and A. Benson, who in later life became Governor of Northern Rhodesia.

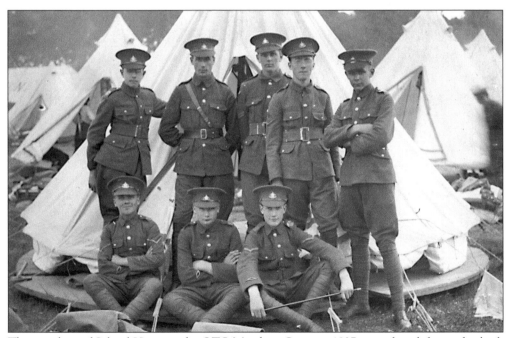

The members of School House at the OTC Mytchett Camp in 1927 were, from left to right, back row: Heeley, A.E.T. Benson, Ward, Bellhouse, Deller. Front row: Eden, Baker, N.S.T. Benson.

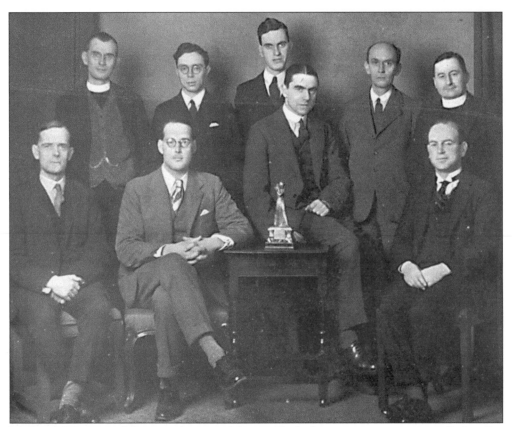

Mr Booth encouraged the introduction of drama. He had a permanent stage installed in Big School and was an active member of the new Staff Dramatic Society. In 1927 the society won the local British Drama League competition, the trophy for which rests on the table.

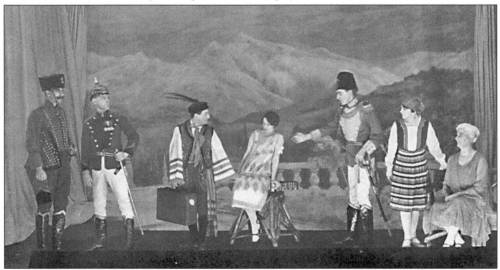

This, the earliest surviving record of a school drama production, shows the Staff Dramatic Society in *Arms and the Man* in March 1928. The driving force behind the society was Harry Barwell, maths teacher from 1922 to 1939.

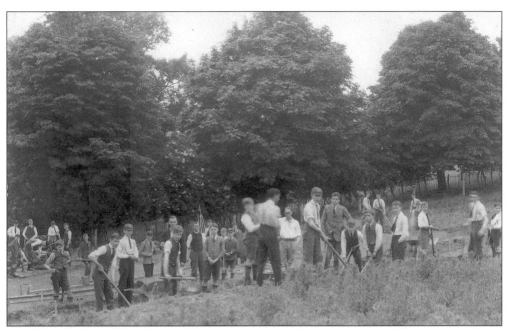

After the purchase of the Valley Field in 1925, Mr Booth decided to use part of the land, to the left of the path leading to it, to create an open-air theatre. He can be seen here in the centre of the workers in 1927. The Revd I. Crump, who put the plans into operation, stands further to the left.

Richard Ryland, seen here on the Travellers' Club visit to Versailles in 1928, helped to build the theatre and took the photograph above. He later became a school governor and benefactor.

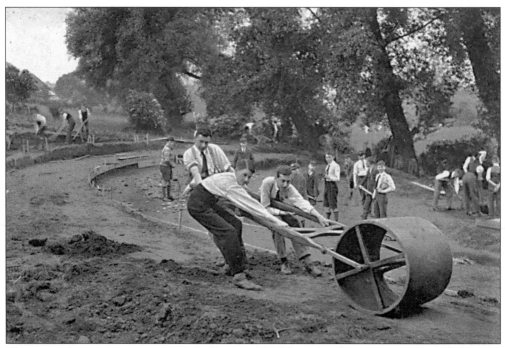

The boys who put in most physical effort into building the theatre were awarded the new Founder's caps.

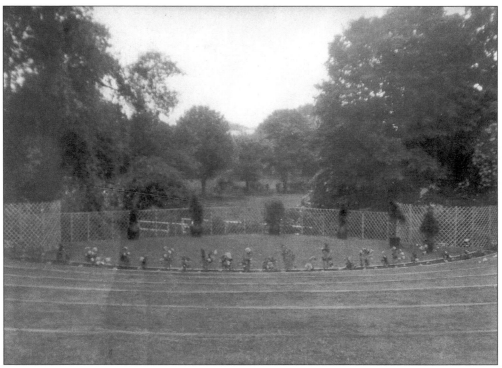

The theatre was completed by 1928 and was used regularly until it fell out of use during the war.

Four
Warren Derry's Heyday
1929-1945

At twenty-nine, Warren Derry was unusually young to be appointed Headmaster but, stern and somewhat reserved, he was old for his years. Convinced that the school could equal the best independent schools in the country, he led the school to new heights of academic success with determination. This was a benign period for the school, with a strong Headmaster and good government. The school had already outgrown its buildings again by 1929 but the growth was in day pupils only. No new boarders joined the school after 1936. Thanks to generous financial support, not least from Gerald Mander, a local industrialist, the school was able to add new facilities. The school survived the war without too much pain, although the coming of women teachers caused some consternation. In 1944, so successful had the school become that it was named as one of the top four grammar schools in the country in the parliamentary debate on Butler's Education Bill.

Taken at the time of Warren Derry's appointment, this view of Compton Road includes two small boys – not pupils – collecting manure left by the horse-drawn traffic for use on local gardens.

Despite his youth, Warren Derry was conservative in spirit, favouring a classical education over science and modern languages. A prominent figure in education at the time, to many students he was an austere figurehead. His staff, however, knew him as a good-humoured and caring man.

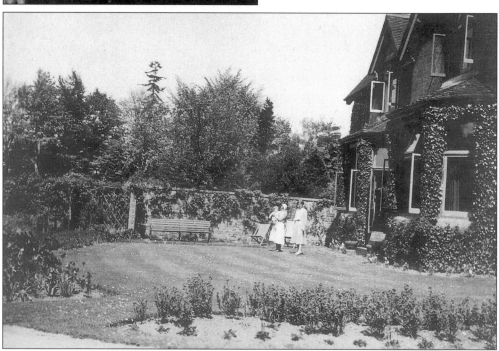

The Headmaster's house and garden. Mrs Derry stands in the garden with her son in the arms of a nurse. The garden wall helped to create a private and secluded area.

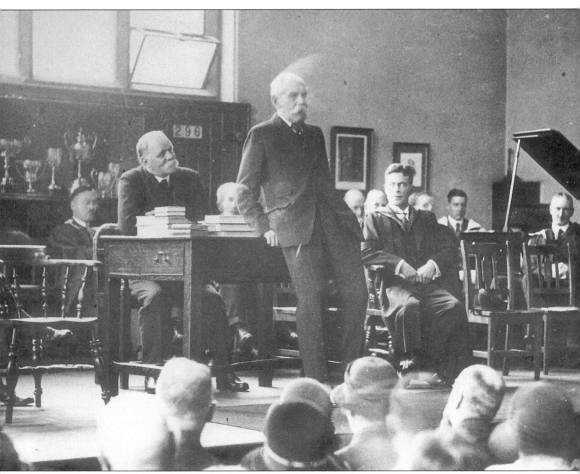

School Founder's Day was held in Big School on 25 October 1929. The speaker is Lord Methuen. On the right is Mr Warren Derry. Seated at the table is the Chairman of Governors, Alderman J.T. Homer, who had 'a boisterous, almost roisterous' career at the school before making his fortune in the Wild West. On his return he became an ardent educationalist and a benefactor of the school. (From the collection of Wolverhampton Archive and Local Studies; photographer: Claude A. Eisenhofer)

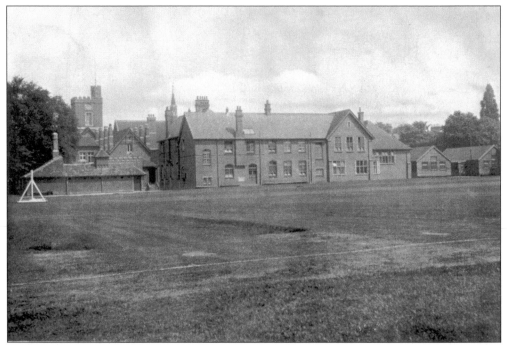

Temporary huts had sprung up around the school by 1926. The two on the right of this photograph housed the two Removes (first forms), and were heated by coke stoves. Some boys knew how to make these smoke out the huts to disrupt lessons.

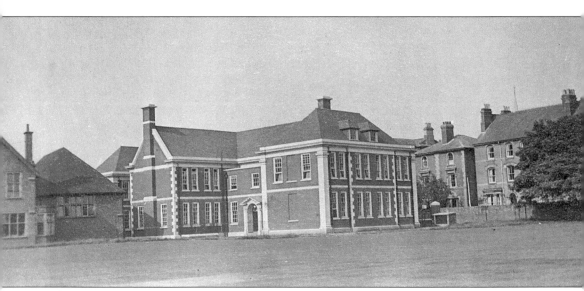

The New Building, or Merridale Building as it later became known, under construction.

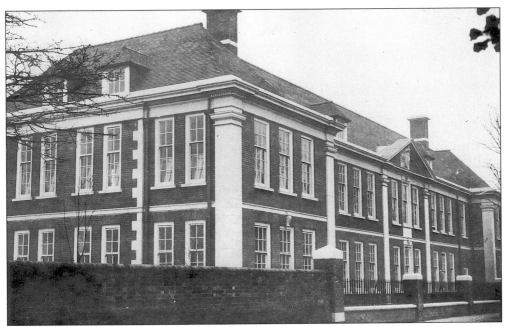

Officially opened in 1930, the New Building was largely a classroom block. It also contained a physics laboratory, library, art room and, at Alderman Homer's particular request, a woodwork room.

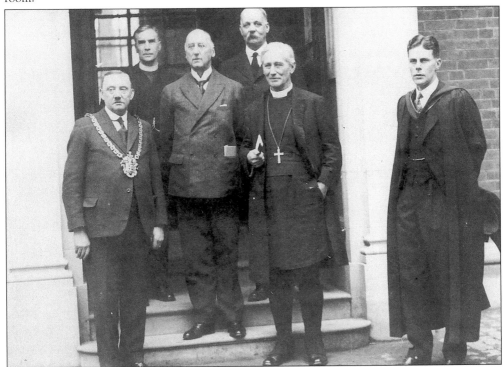

At the ceremonial opening Mr Derry stands to the right of the official party. From left to right, behind are Revd R.L. Hodgson and J.T. Homer, in front are the Mayor (Alderman Haddock), Lord Harrowby and the Bishop of Lichfield.

Mr Crickmay, standing behind the athletes of 1929, was on the staff from 1911 until 1936. Second Master from 1920, he was fondly remembered as a teacher, referee and umpire. From left to right, back row: Egginton, Fellows, Crawford, Deller, Ross, Heeley, Halldron. Front row: Armer, Fanshawe (captain), Morgan.

The school's first scout troop was founded by Mr Geoff Sheen in 1930. From left to right, back row: Bellingham, Fletcher, Bugg, Birch, Evans, Ward. Middle row: Ecclestone, Cholmondley, Devey, Margary, Fullwood, Clitheroe. Front row: Joseph, Shuttleworth, Davis, Griffin, Lenfestey, Gethin.

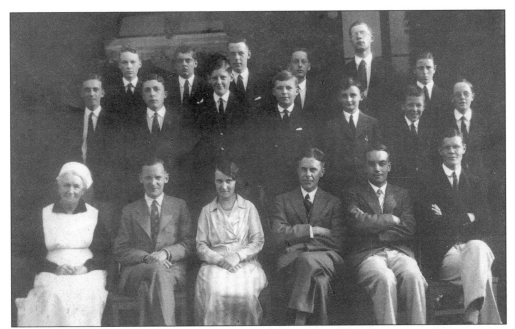

School House was small in 1933. From left to right, back row: MacKenna, Walley, Juckes, Parkes, Bourne, Jones. Middle row: Sage, Craddock, Anderson, Ridley, Pollitt, Joynson, Silvers-Till. Seated: Kim, Mr Taylor, Miss Squire, Mr Derry, Mr Reed, Wilson. Both MacKenna and Anderson died in the Second World War. In 1936 School House numbers fell so low that boarding was no longer advertised.

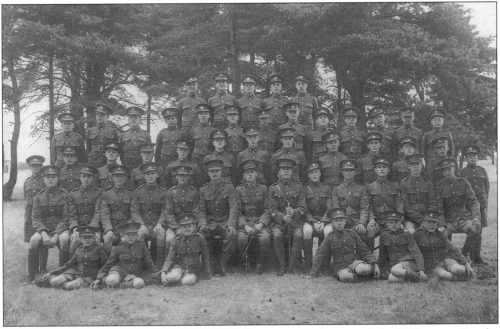

The OTC continued to flourish and its members are seen here at their 1934 camp. On the seated row starting from fourth from the left are Bagnall, Evans, Mr R. Holmes, Captain H. Barwell, Sergeant-Major Morse, -?-, -?-, Tildesley and Jones.

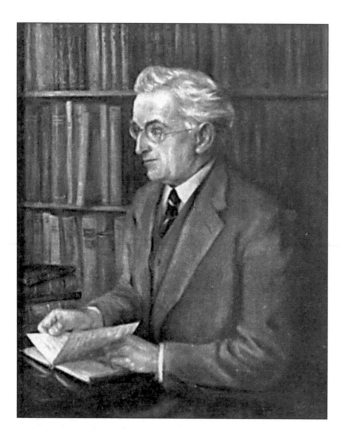

Mr Gerald Mander of Mander's Paints was a major benefactor in this period. An important local historian, he wrote the original history of the school. He was a governor from 1913 and Chairman of Governors from 1934. This portrait was painted in 1951.

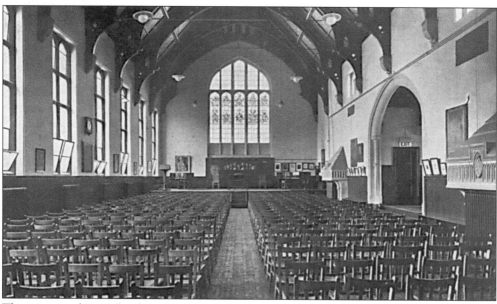

This picture of Big School in 1936 shows the end window as it was after it was repaired and enhanced with stained glass in 1934 as a result of Gerald Mander's generosity.

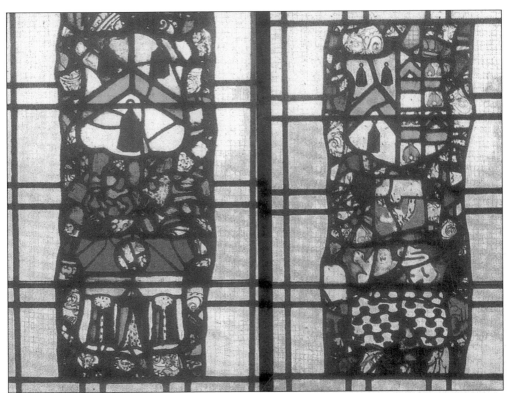

These panels containing stained glass,
originally given by Sir Stephen Jenyns to
St Andrew Undershaft in London in about
1525, were secured for the school by Mr
Mander, after they had originally been
sent here for safekeeping from bombing in
the war.

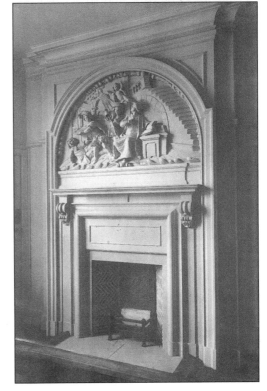

A new Masters' Common Room was built
at Mr Mander's expense in 1939. Now
called the Gerald Mander Room, it contains
this marble fireplace, which includes an
example of seventeenth-century carving
found by Mr Mander in Cambridgeshire.

Not all of the huts of the 1920s disappeared in 1930. Music continued to be taught in this hut until the opening of the music block in 1969.

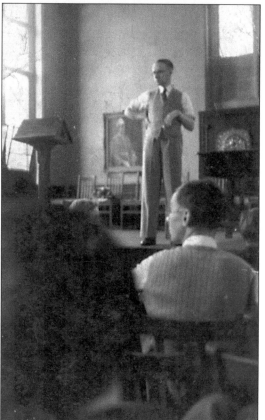

Frank Rust started his forty-year career as music master in 1937, when this photograph was taken. He is standing on the stage in Big School. Thanks to him the status of music in the school increased rapidly.

Mr Rust is here seen talking to a group of boys in a classroom with Big School visible through the open door behind him.

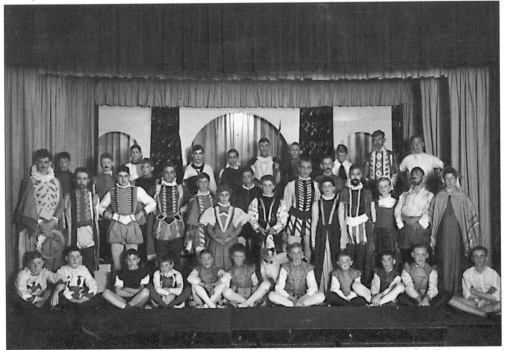

Drama continued to thrive at the school thanks to Mr W.H. Bailey. This 1938 production of *The Taming of the Shrew* starred A.W. Price as Katherine, F. Powis as Petruchio, W.F. Joyce as Sly and J.V. Barnett as Baptista. Mr Bailey died in the war.

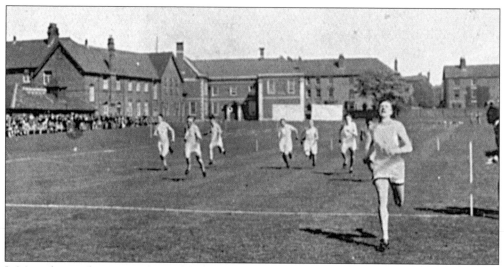

J. Morrish was the outstanding athlete of the 1938 Athletic Sports Day, winning five events with record times. He won this 100yd race in 10.4 seconds.

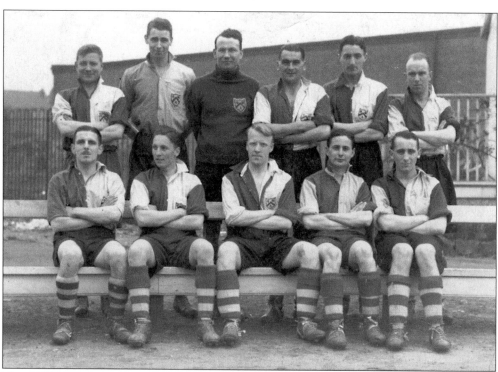

The OWFC won their last pre-war match 2-1. From left to right, back row: Max Westwood, Les Connolly, Roger Holder, Tom Butler, Ray Corbett, Bill Yorke. Front row: Hope Till, A. Blakemore, Ken Paterson, Bill Swallow, Mick Fereday. Connolly died in the war.

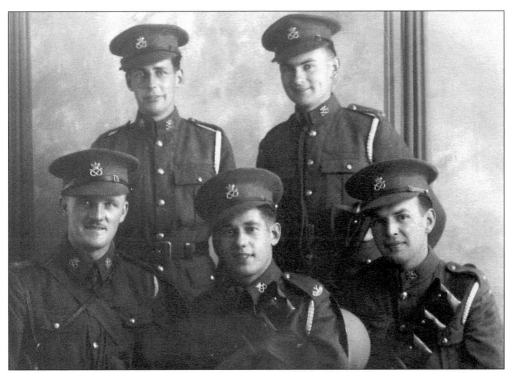

Five former members of the school's OTC who joined the Staffordshire Yeomanry when war broke out in 1939. They are, clockwise from top left, David Barnlett, Ken Rolf, Michael Gurmin, Frank Littler and Tom Drury.

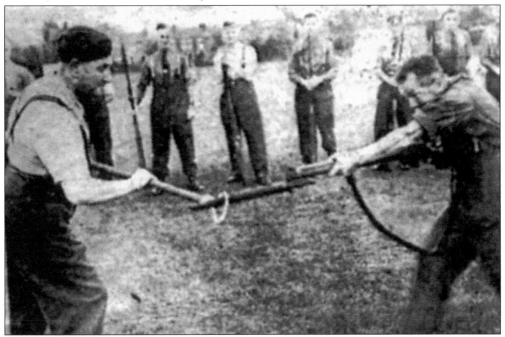

The Home Guard being trained by CSM F. Rudge and Lt E.T. Morse in the school grounds in this *Express and Star* photograph of 1941.

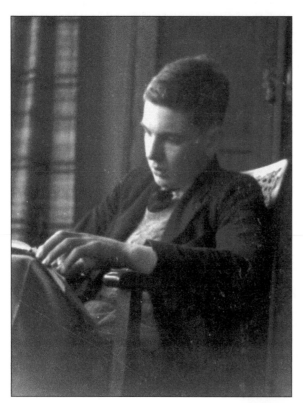

A sixth-form pupil in 1941, John Roper went up to Oxford, but, like many of his generation, his studies were disrupted by the war. He joined the RAF for the duration.

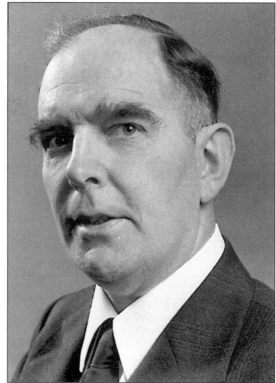

Mr Roper continued to support the school throughout his life. A solicitor and local historian of note, he became Chairman of Governors in 1977 and played a major role in helping the school through to independence.

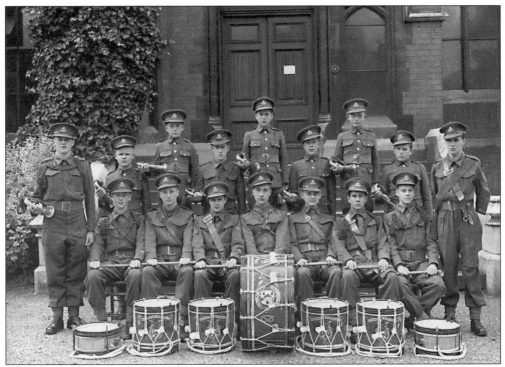

The school's Air Training Corps was founded in February 1941 as a direct result of the government's drive to train more pilots for the war after the Battle of Britain. In 1943 the ATC band was directed by Sgt G.B. Wolverson.

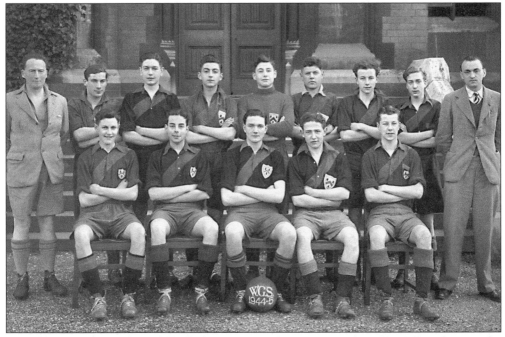

Travel restrictions made it difficult for teams to play away matches. Harry Brogden, on the right, handed over the coaching of football to L.J. Evans, on the left, in 1943.

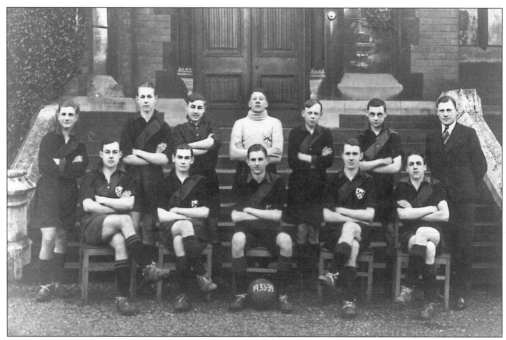

Harry Brogden, on the right of the 1933/34 team, was teacher, Second Master and successful football coach by turns from 1930 to 1943. From left to right, back row: -?-, -?-, -?-, Jones, Latham, -?-. Front row: -?-, Hodges, Stokes, -?-, Boyd. The other team members are Evans, Darby, Stagg, Eccles, Marsh and Beddow. Boyd and Stagg died in the war.

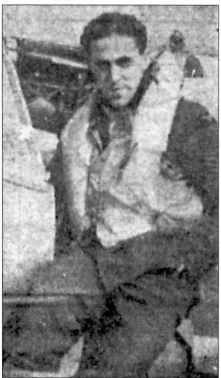

A Spitfire pilot in the war, Boyd was featured in the *Express and Star* on 25 October 1941, after being shot down and rescued from the Channel. He survived that time – but died when he was shot down over France in 1943.

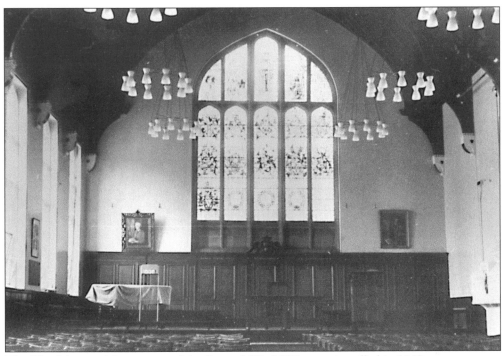

The War Memorial for victims of the Second World War was installed in 1948.

ANDERSON, B. S. N.	GRAHAM, E. L.	SHARRATT, L. K.
ARNOLD, D.	GUEST, P.	SHORTLAND, B. A.
BADGER, J. S.	HARTILL, J. E. A.	SMITH, N.
BAILEY, W. H. (Master)	HERBERT, P. R.	SMITH, J. O. N.
BANKS, E. F.	HILL, D. A.	SOUTHALL, G.
BARRETT, T.	HILL, R. J. T.	STAGG, M. A.
BECKWITH, N.	HOLLAND, A. E.	STANSFIELD, K. R.
BEESTON, A. E.	HOLMES, C. A.	STEWARD, J. E.
BOYD, R. J.	HOPKINS, H. J. A.	STOCKING, P.
BURGESS, J. H.	HUNTER, R. C.	STOY, S.
BURTON, D. C. N.	JEAVONS, A. C.	TAYLOR, E. M.
CLARK, J. M.	KYNASTON, N. A.	TECTOR, L. E. M.
CLARKE, H. T.	MACKENNA, R. A.	THOMAS, W. J.
CONNELLY, C. L.	MARKHAM, E.	TIMMIS, W. A.
COOPER, R. F. H.	MUSSELWHITE, D. R.	TURNER, H. J.
CORBETT, E. H.	OWEN, J.	TURTON, F. P.
CREED, G.	PEDLEY, A. H. K.	WALL, C.
DAINTY, E. M.	RICE, W. A.	WALLINGTON, W. G. V.
DAVIES, M. C.	RICHARDSON, C. F.	WEBB, K. D.
FELLOWS, P. W.	ROBERTSON, A. A.	WEBSTER, L. A.
FIELD, D. H.	ROLLINSON, J. D.	WELLINGS, F. R.
FOSTER, D.	ROWLEY, C. A.	WESTON, S. J.
FOSTER, E. M.	RUSHTON, W. T.	
GLOTHAM, W. J.	SAMBROOK, W. D.	

The names on the memorial as listed in the 1950 *Wulfrunian* magazine.

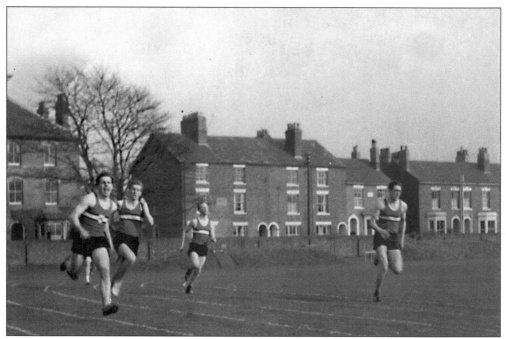

The school's air-raid shelters were a reminder of the war for many years. They can be seen here behind the relay runners at the 1962 Sports Day. From left to right: W.C. Rees, S. Ross, M.J. Shuttleworth, P.H. Tibbetts.

Another reminder of the war was the absence of the school railings, sacrificed to the war effort at the beginning of hostilities. They were not replaced until the 1980s. (From the collection of Wolverhampton Archive and Local Studies)

Five

The State School
1945-1955

Butler's Education Act of 1944 set up a new system of education throughout the country. There were meant to be three tiers of schools – grammar schools, technical schools and secondary moderns, although few technical schools were built. Several kinds of grammar schools were set up, with differing levels of state support, in order to enable church schools and other semi-independent foundations to survive. Like all Headmasters of old direct grant schools, Mr Derry had to negotiate the school's position in the new order with the Local Education Authority. It became clear that the school could only remain a direct grammar school by increasing its fees to unreasonable levels. In 1949 the school accepted voluntary aided status, which ended fees and gave the local authority financial control and substantial influence over the school's affairs. So well did Mr Derry manage the transfer that the pupils noticed nothing, and their parents noticed only that all places were now free.

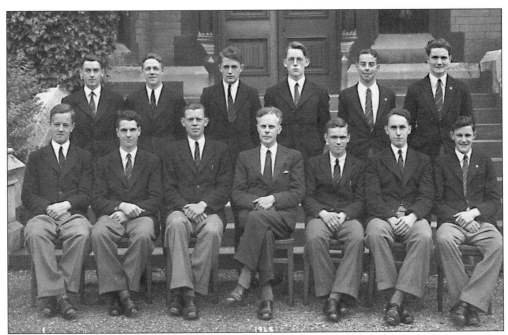

Warren Derry sits surrounded by the prefects of 1945. From left to right, back row: Lawley, Hayes (?), Cooper, Baker, Norgrove and Walton. Front row: Stephens, George, Mernagh, Mr Derry, Ling, Hamflett, Till. The third-year sixth system meant that they were older than prefects today.

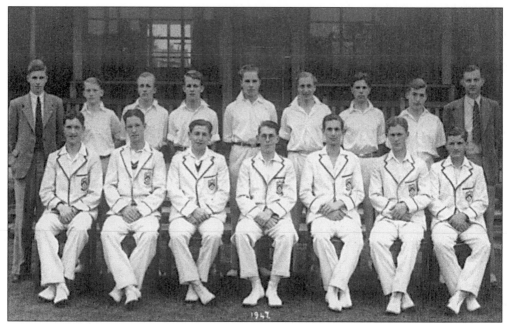

In May 1947 the Bourne brothers bowled out Tettenhall College between them for 48 runs. From left to right, back row: -?- (scorer), McGookin, Smith, Horsfall, Gennoe, Shale, Morrall, Jay, Mr Noel Stokes (coach). Front row: D.C. Bourne, P.O. Bourne, Richards, Lee (captain), Fellows, Jump, Willis.

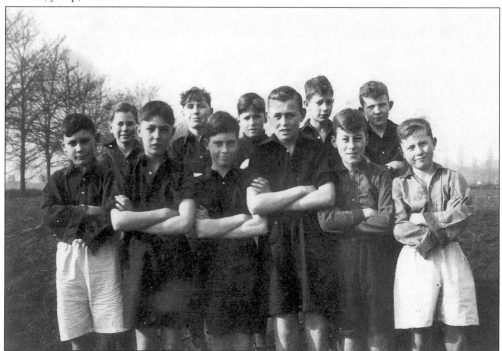

These under-13 footballers met on the Valley Field in 1947/48. From left to right, back row: M.B. Cunningham, B.E. Davies, K. Ralph, D.G. Beaman, J. Ingram. Front row: G. Turner, C.G. Carter, M.S. Brayshaw, S.H. Palmer, T.A. Jordan, B.S. Jones.

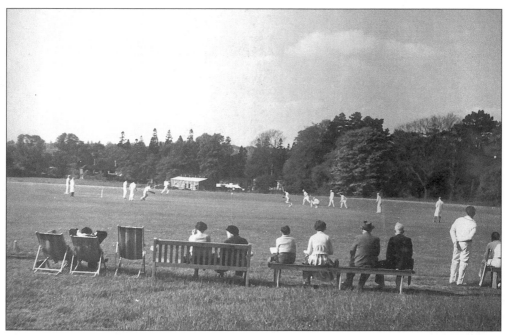

The grounds at Castlecroft were bought in 1948 by the Old Wulfrunian Association to commemorate the war.

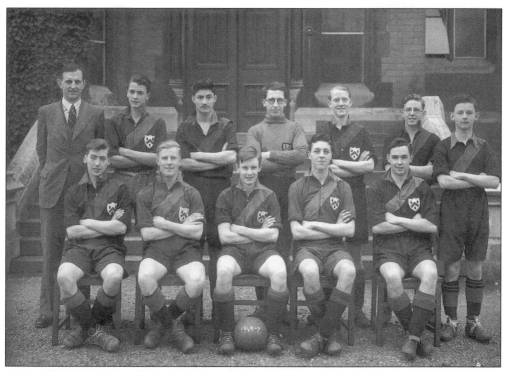

The members of the First XI football team of 1948 were, from left to right, back row: Stokes, Mills, Everall, Hughes, McGookin, Jones, Chavasse. Front row: Jay, Whitehouse, Ward (captain), Boulton, Richards. Judge M.B. Ward has been Chairman of Governors since 1981.

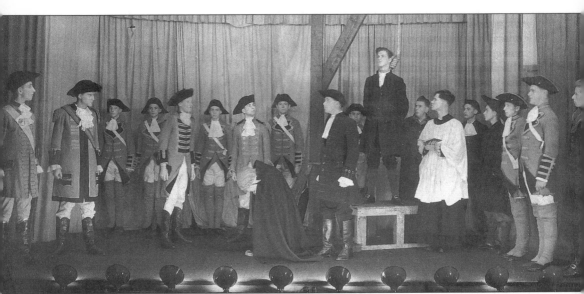

In the 1948 production of *The Devil's Disciple*, D.J. Moreton played Richard Dudgeon. Also among those pictured are Williams, Robinson, Adey, Craddock, Handley and Morrish.

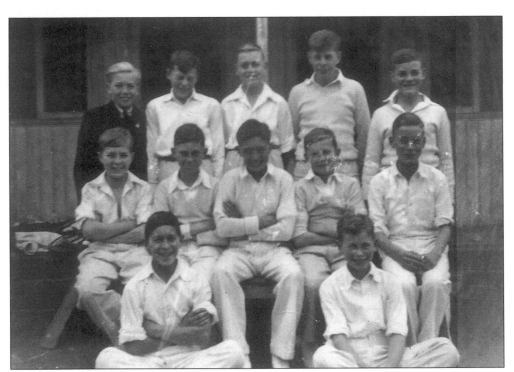

The members of this team of young cricketers in 1948/49 were, from left to right, back row: Humphries, Cooksey, Palmer, Perrin, Warnock. Middle row: Sergeant, Brayshaw, Carter, Jones, Jordan. Front row: Berry, Cunningham.

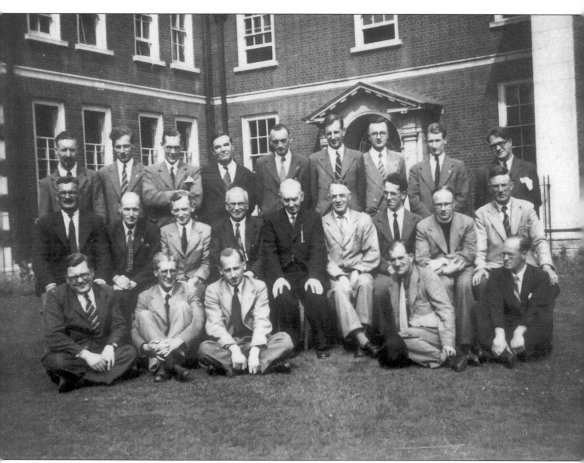

The staff of 1948/49 stand outside the Merridale on the retirement of Mr J.E. Walker after thirty years' service. From left to right, back row: Messrs Allan, Morris, Batty, Wilson, Stephenson, Stokes, Noel, Stocks, Ewan. Middle row: Holmes, Davies, G. Taylor, Carhart, Walker, Dance, Sheen, Rust, Owen. Front row: Siveter, Edwards, Carr, Jones, Viner.

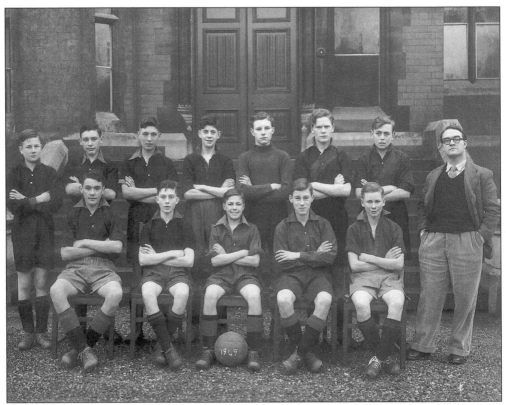

This under-15 team, trained by Mr C. Ewan, won all its matches in 1949. From left to right, back row: R.H. Caddick, G. Turner, C.G. Carter, G.R. Franklin (?), J. Dickenson, H.H. Nuttall, S.H. Palmer. Front row: R. Griffiths, M.S. Brayshaw, P.H. Evans (captain), T.A. Jordan, M.B. Cunningham.

Michael Warren, later an internationally renowned painter of birds, sketched this view of the school while he was a pupil here from 1949 to 1954.

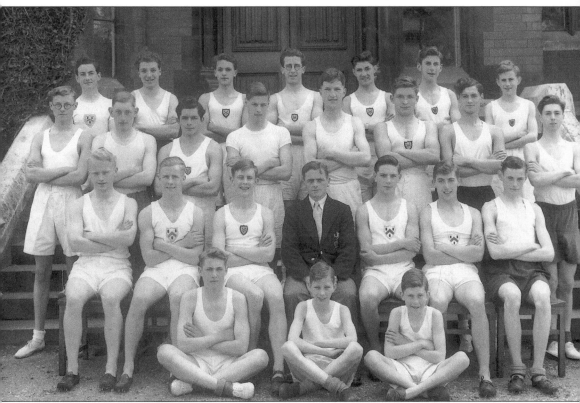

This team of athletes went to the first meeting of the North West Midlands Schools' Amateur Athletic Association on 8 May 1948. From left to right, back row: Hughes, Bayliss, Mills, Hughes, Everall, Heaton, Ransom. Middle row: Johnson, Riley, Willis, Smith, Bourne, Price, Oakley, Houghton, Rogers, Whitehouse, Ward, Mr H. Robertson, Waugh, Jay, Hinde. Front row: Fisher, Beaman and Brayshaw.

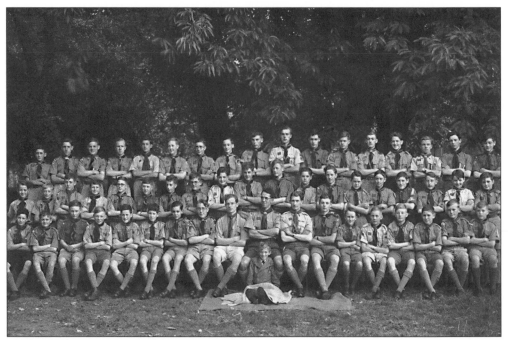

Mr Geoff Sheen is seated in the centre of the Scouts in 1949, between leaders Ted Carpenter, Les Morris, Tony Stocks and Michael Bickerton. At his feet is polio victim John L. Weston who died in 1953.

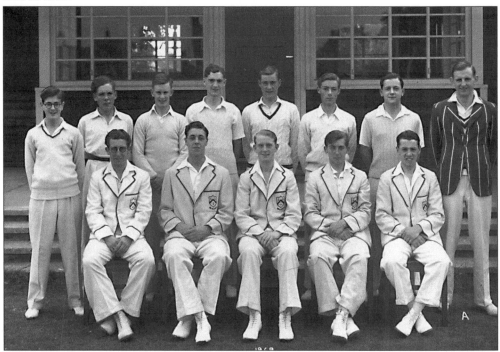

The 1949 cricket team stands in front of the pavilion built in 1938 thanks to the generosity of Major S.J. Thompson. From left to right, back row: Ray, Ward, Brayshaw, Holland, Spencer, Peacock, Mr Stokes. Front row: Hughes, Boulton, McGookin, Jay, W.D. Locke.

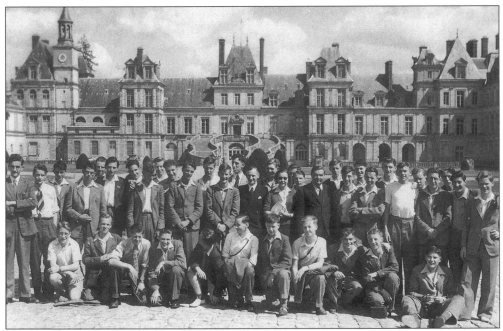

In 1949 The Travellers' Club organized the school's first trip to the Continent since the war. Mr Taylor, leader of the expedition, stands in the centre with M.B. Ward on his left, in front of the Palace of Versailles.

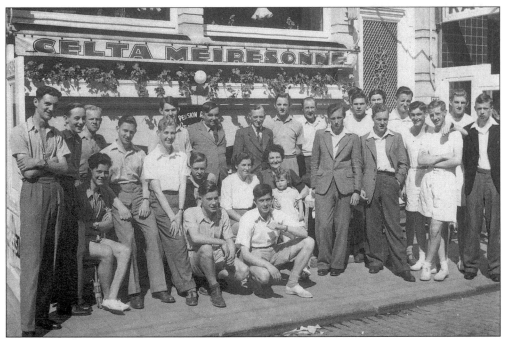

The destination in 1950 was Blankenberge in Belgium. Mr R.N.D. Wilson and Mr G.J.G. Taylor stand in the centre.

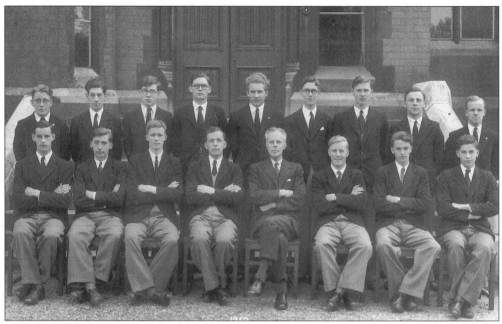

The prefects in 1950. From left to right, back row: Carpenter, Harris, Sharp, Lepper, Williams, Crickmore, Bishop, Amos, Sherratt. Front row: Sharp, Jay, Price, Craddock, Mr Derry, Whitehouse, Mills, Hartill.

A group of senior boys stand outside the Merridale in about 1950. From left to right, back row: Evans, Holder, Holland, Jones, Mann, Blower, Hampton, Turton, Smout, Foster. Front row: Hooper, Dickenson, -?-, Steadman.

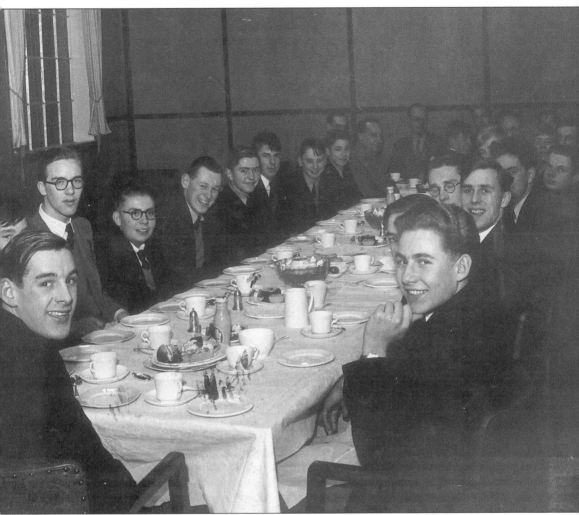

The thriving Scientific Society visited Hardy Spicer's propeller factory in January 1950. On the left side from the front: Sharp, Riley, -?-, Nicholls, -?-, Wright, Griffiths, Perrin, Hately, Hale and Mr Carr. Against the wall: Mr Batty and Mr Viner. On the right: Williams, -?-, B.W. Jones, and others including Evans, Pinches, Whittall, Fidler and Brett.

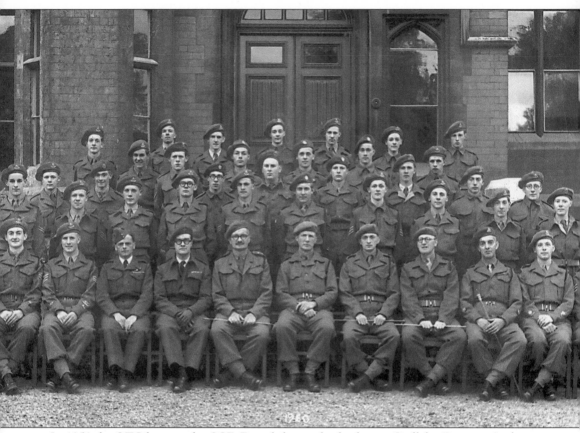

In 1950 the OTC became the CCF. From left to right, back row: Griffiths, Preston, Anderson, Adey, Riley, Turton. Second row: P.J. Brayshaw, Titley, Wright, Spencer, Jones, Banson, Lloyd. Third row: T. Sharp, -?-, Fletcher, J.E. Sharp, Handley, Sadler, Bishop, Jay. Fourth row: Sherratt, -?-, Lepper, Hills, Williams, Price, Harris, Sansom. Front row: Hughes, Whitehouse, P/O Robertson, F/O Ewan, Capt. Holmes, Maj. Owen, Lt Stephenson, Capt. J. Taylor, Simpson, Craddock, Hartill.

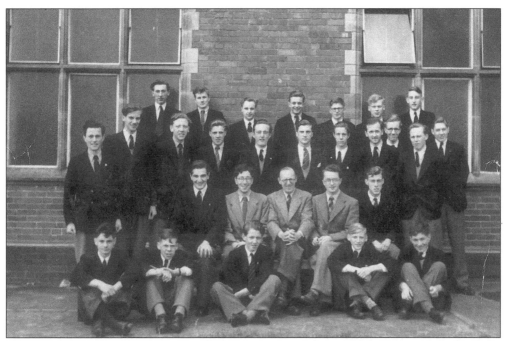

The Classical Sixth forms and staff in 1952/53 were, from left to right, back row: Davis, Caddick, Nott, Bradley, Turner, Lyle, Tiernay. Second row: Silk, Wisker, Parker, Burgess, B. Gilmore, Holloway, Howell, Watkins, Beckett, Cox, Watkis. Third row: Shingler, Mr B.H. Polack, Mr J.A. Taylor, Mr B.F. Sherdley, Jordan. Front row: L. Holmes, Lewis, P. Locke, Foster, Withers.

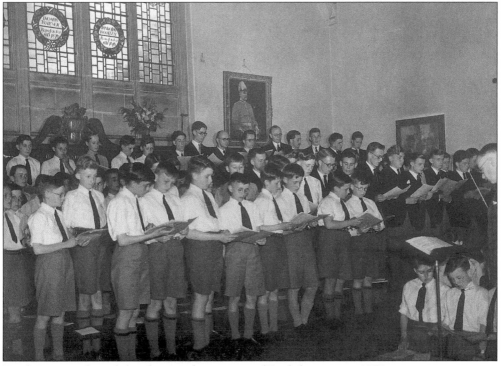

Frank Rust conducted the choir in this concert of English music in 1952.

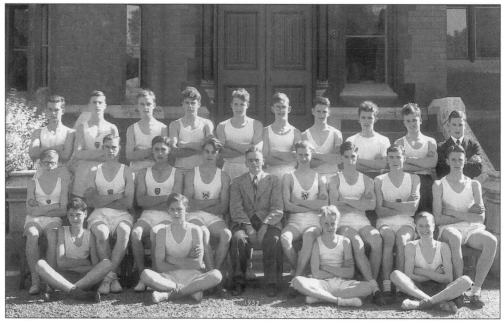

Mr Hugh Robertson trained the athletes of 1952. From left to right, back row: Ling, Holloway, McMillan, Perrin, Alford, Wright, Roseblade, Wynne-Evans, Wellings, Smout. Middle row: Turner, Banson, Carter, Mills, Ransome, Hayes, Cooksey, Holder. Front row: Holmes, -?-, Helme, Rhodes.

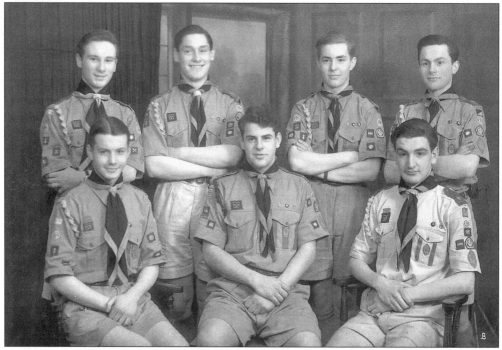

In 1953, out of twenty-eight Senior Scouts, seven became Queen's Scouts, a remarkable achievement. From left to right, back row: Ian Bremner, Martin Riley, Eddie Sergeant, Richard Silk. Front row: Alan Locke, John Perrin, Fred Shingler.

Mr Tony Stocks became Scoutmaster in 1950. In 1953 the scouts were, from left to right, back row: Baker, Johns, Rees, Hayward, Jones, Reade, Cox, Percival, Fowler, Blake, Waddams, Spencer, Marks. Second row: Napier, Bryan, Hyde, Cooper, Kays, Roberts, Spence, Bailey, Holden, Hollier, Checketts, George, Johnson. Third row: Pritchards, Foster, M. Shuttleworth, Allen, Dixon, Carpenter, Mr Polack, Mr Stocks, Mr Cox, Ken Woodward, Nicholls, Williams, R. Shuttleworth, Scholey. Front row: Saunders, Moore, Bott, Richards, Louis, Wilson, Haynes, Gough, Clark.

Pictured upon the retirement of W.H. (Froggy) Carhart in 1955, the staff are, from left to right, at the very back: Messrs Mercier, Parker, Allan, Noel. Main back row: Messrs Sherdley, Polack, Viner, Till, Hughes, Stokes, Porter, Sanderson, Beale. Middle row: Messrs Whitehouse, Wrigley, Stocks, J. Taylor, Batty, Merrett, Siveter, Robertson, M. Taylor. Front row: Messrs Dance, Owen, Holmes, Carhart, G. Taylor, Rust, Davies.

Six

Ernest Taylor
1956-1973

By 1956 the austerity years after the war were over. The need for new buildings, especially science and dining facilities, had already been apparent as Mr Derry's long headmastership came to a close. Under the terms of the school's voluntary aided status, financial responsibility for the exterior of the buildings lay with the school. When Ernest Taylor was appointed in 1956 he opened the School Building Fund and soon afterwards encouraged the setting up of The Friends, who have raised valuable sums for the school ever since. So successful was this appeal that the Derry Building, with its science laboratories, classrooms and dining room, was completed in 1960. A highlight of these years was the Queen's visit to the school in 1962. Sufficient funds were raised to enable the Hallmark Building to be built in 1968, to replace the old Junior School.

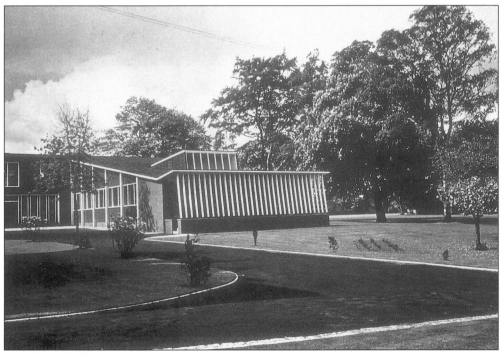

The Derry Building as it looked when it was new.

Mr Ernest Taylor was already an experienced Headmaster of national standing upon his appointment in 1956. A scholarly historian, remembered for his open, caring manner, his approach to education was more liberal than that of his predecessors.

Lt-Col. R.F.G. Holmes, seated on the left with the CCF band of 1956, commanded the CCF from 1955 to 1963. In 1956 he was promoted Second Master upon the retirement of Mr Carhart. His role was crucial during Mr Taylor's absences at national and international conferences. Major John Wrigley sits on the right.

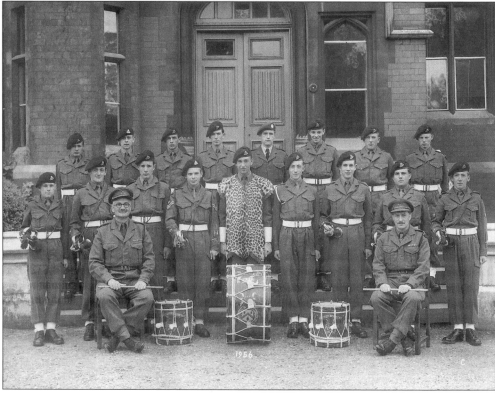

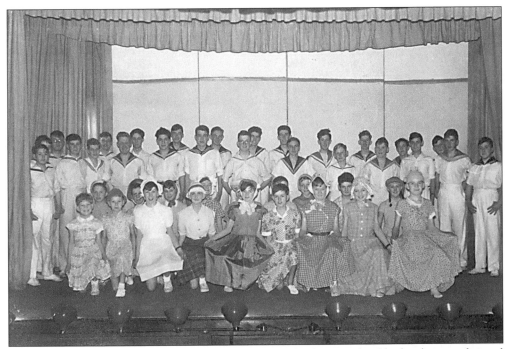

The cast of the 1956 Scouts gang show *Let's Go Gay*. At this time 'gay' had only its traditional meaning of cheerful!

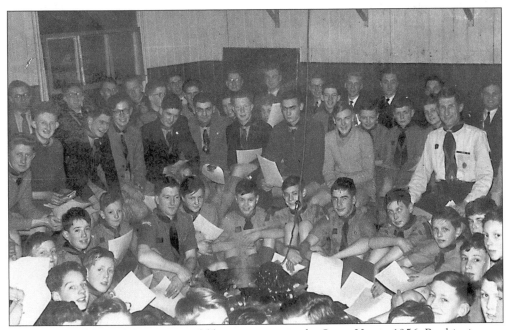

The Scouts celebrated their twenty-fifth anniversary in the Scout Hut in 1956. By this time no fewer than a fifth of the boys in the school were Scouts.

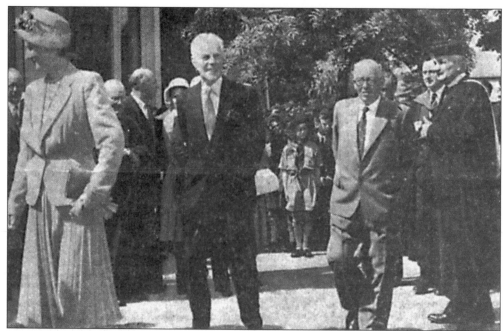

On 28 May 1960 the *Birmingham Post* reported the opening of the Derry Hall after the school had successfully raised £50,000. Mr Warren Derry, in the centre, opened the building. To his left stands Mr Henry Hallmark, Chairman of Governors, whose legacy to the school was most valuable. Mr Taylor is on the right.

The school's chess team won the *Sunday Times* National Schools' Chess Tournament in 1960. From left to right, back row: Mr B.H. Polack, Wernick (reserve), Wingfield, Kelly. Front row: Winbow, M. Stevenson, Greenhaugh, Sadler.

The school's first biology laboratory was opened in 1957 when Mr R.E. Lister was appointed to introduce the subject. In 1960 he took this group of sixth formers on a biology field course at Port Erin on the Isle of Man.

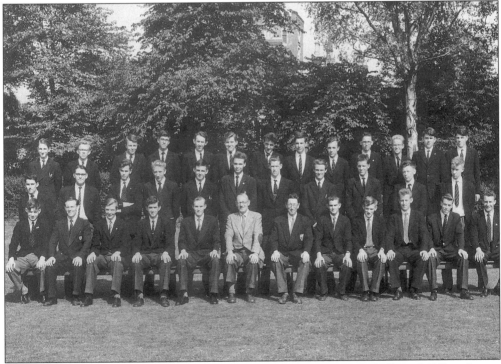

The houses were now called Homer, Jenyns, Marston, Moreton, Nechells and Offley. Jenyns House is pictured here in 1961 with housemasters Mr J.A. Taylor and Mr B.H. Polack.

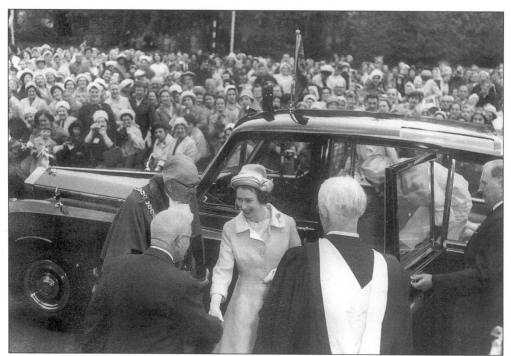

HM Queen Elizabeth II was welcomed to the school by Mr Henry Hallmark upon her arrival at the school on 24 May 1962.

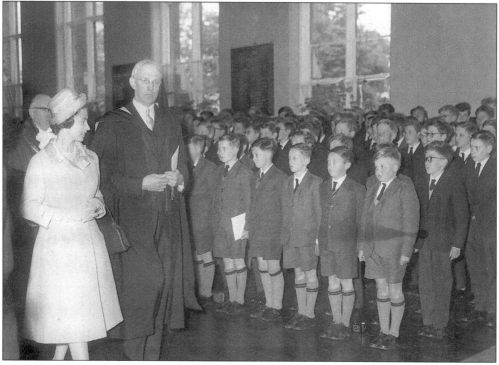

Mr Taylor escorted the Queen into Big School, where she unveiled the plaque in honour of her visit, which is still to be found to the left of the stage.

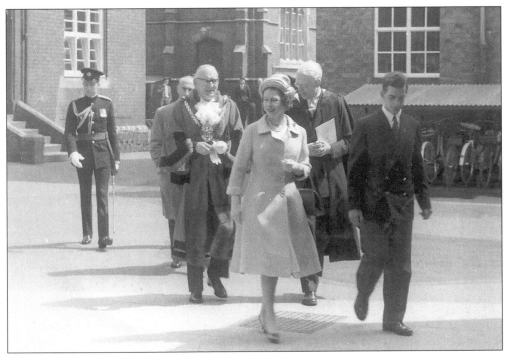

The Queen crossing the courtyard to the Derry building with Head Boy W.C. Rees. Behind him is the Headmaster with the Mayor, Alderman Birch.

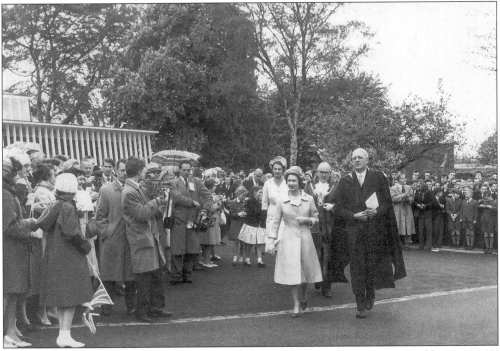

The Queen with Mr Ernest Taylor outside the then recently opened Derry Building in 1962. The view behind was transformed when the building named after Henry Hallmark was completed in 1968.

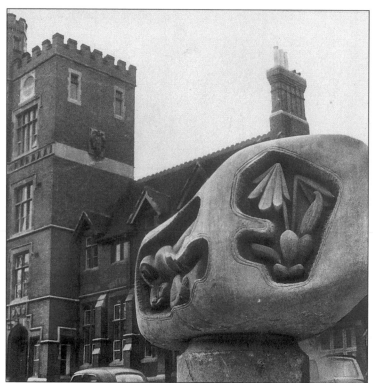

The Pebble, sculpted by Glynn Williams (OW 1950-1955) won the Gulbenkian Award. Designed on a large scale, with a location on the Derbyshire-Cheshire Moorland in mind, the reliefs personify the four seasons. It was given to the school in 1962.

The old courtyard can be seen through the Derry Hall behind the Second XI football team of 1961/62. From left to right, back row: Fullwood, Brindley, Salter, Hallett, Rees, Ireland. Front row: Pursehouse, Nelson, Cribb, Bayliss, Pearson.

The athletes of 1962 included eight of national standing. From left to right, back row: Edwards, Norgate, Fullwood, Benton (?), Priddle, Wright, Blakemore, -?-, Johnstone. Front row: Smith, Roberts, Mr T. Whitehouse, Rees, Pursehouse, Ross, Robinson. Sir D.J. Wright later became HM Ambassador to Japan.

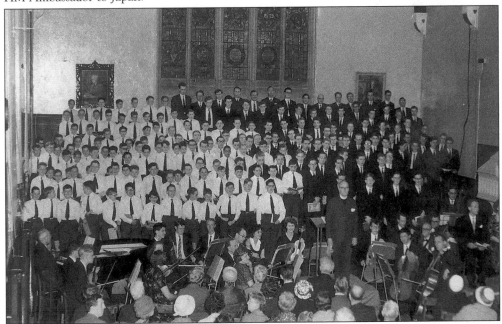

Increasing numbers took part in musical activities. *Messiah* was performed in Big School in 1962.

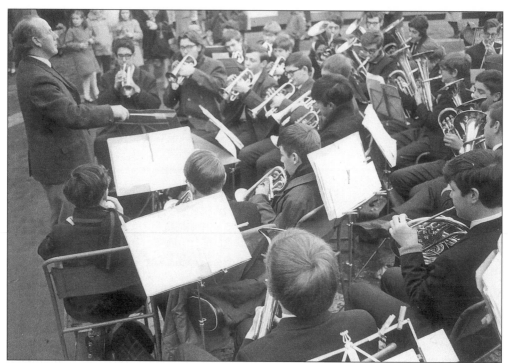

Mr Bert Powers was appointed to introduce brass into the school in 1965. He conducted the band in this first Christmas fund-raising concert in the Wulfrun Centre in 1968. Later that school year the band won the brass section at the Wolverhampton Music Festival.

The Derry courtyard in 1968, with the Junior School in the background.

The gallery choir in Britten's *St Nicolas* in 1968, with Mrs Florence Darby and Mr Frank Rust, included: Robinson, Reaves, Mondon, Carter, Clayton, Simpson, Pettet, Warr, Hughes, Aston, Goodwin, Moule, Wilcox, Price, Rixon and Smallman.

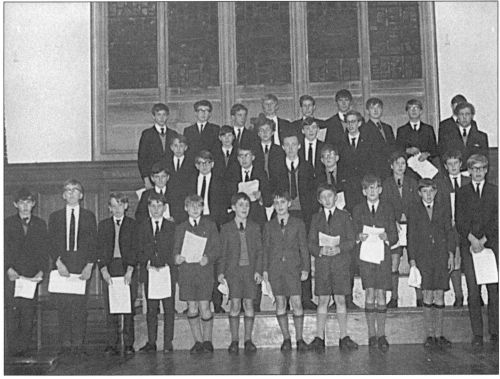

Each house had its own choir. This is the Homer House choir in 1968.

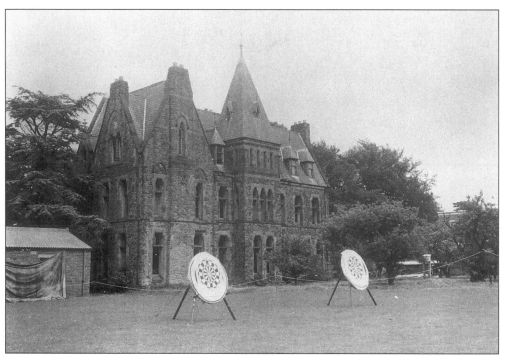

The Junior School immediately before its demolition in 1968, with the Derry building just visible in the background. (From the collection of Wolverhampton Archive and Local Studies)

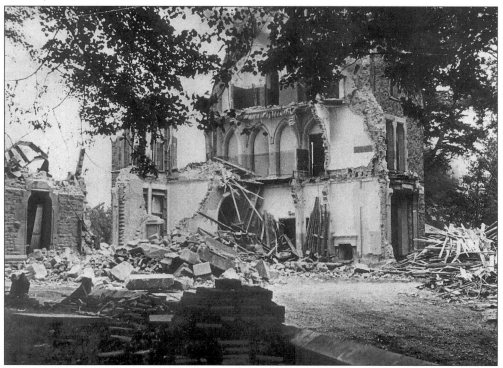

The demolition of the Junior School was recorded by the *Express and Star*.

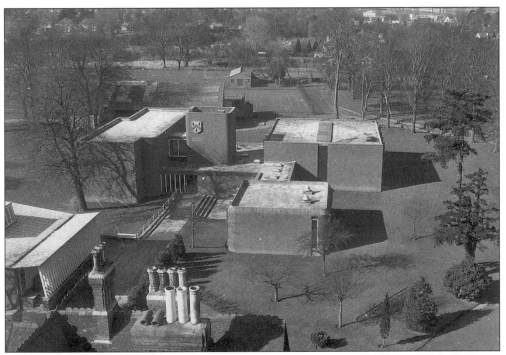

Viewed here from the top of the tower, the Hallmark Building was opened in 1970 by Mr Henry Hallmark. The Picton Memorial Music Room, opened in 1969, is in front of it. Michael Picton (OW 1940-1945) died in 1949.

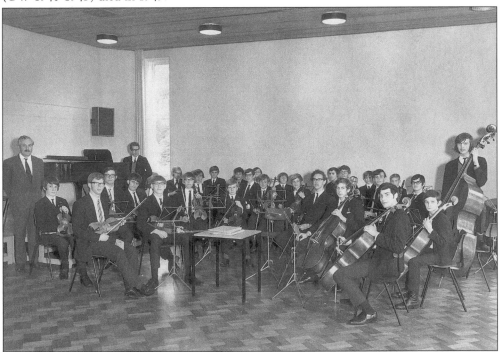

Mr John Wrigley with the orchestra in the new music room. Philip Crook is at the piano, Tim Calloway leads the orchestra, Andrew Woods the cellos, and John Green plays double bass.

Jenyns House Seniors won the Cock House Cup in 1969/70. From left to right, back row: Fox, Ward, -?-, Clarke, -?-, Issitt, Redler. Middle row: King, Aggleton, Watkins, Watson-Wood, -?-, Cordey, Thomas. Front row Yeadon, Lawrence, Stanford, Hosking, Knowles, Somerville, Page, Murray.

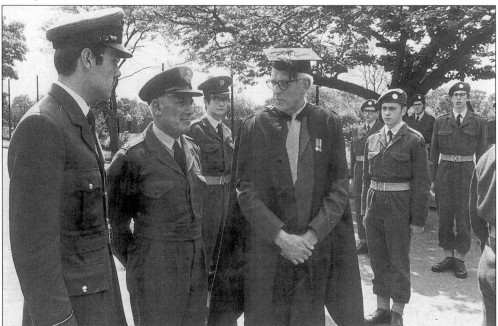

The final inspection of the CCF before it was disbanded in 1971. From left to right, FO James Giles, Flt-Lt. Norman Whitehouse, RAF section commander and chemistry master, WO Tim Lawrence, Mr Taylor and to his immediate right Reg Brindley, who became an RAF officer.

Seven
The Fight to Survive
1973-1978

When Tony Stocks became Headmaster in 1973, he faced an unenviable task. Negotiations over plans to include the school within the comprehensive education of the town had already been continuing for five years. Gradually it became clear that the very survival of the school was at stake. This came to a head in 1977 with the decision of the Local Education Authority to cease to send boys to the school. Accepting that there was no option but independence, Mr Stocks, backed by an exceptional team of governors, did all he could to save the school. He decided, however, to retire in 1978 and hand over to a younger man, recognizing the enormous effort that the school faced if it was to pull through.

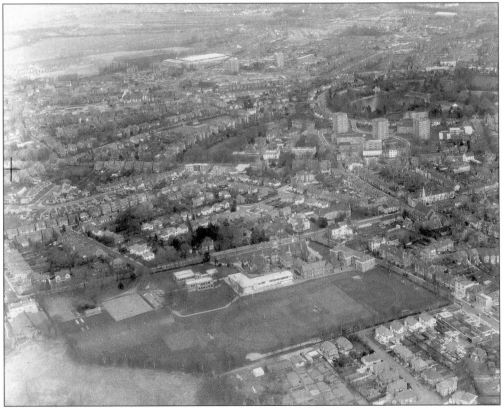

The Merridale site, as it was referred to in Education Authority documents of the time, seen from the air in the 1970s.

A man of high principles, firmly committed to the grammar school ethos, Tony Stocks taught history at the school from 1947 to 1957, before leaving to become Headmaster of Sir Thomas Rich's School in Gloucester. His knowledge of the school and experience as a headmaster were important at this time.

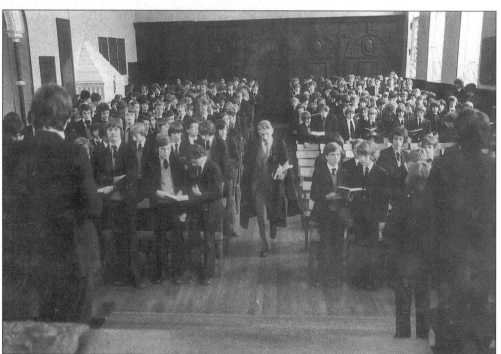

The Headmaster coming to the stage of Big School to take assembly.

Mr Frank Rust ended his thirty-five years at the school with four nights of concerts in July 1973. The choir sang *The Music Makers* by Elgar.

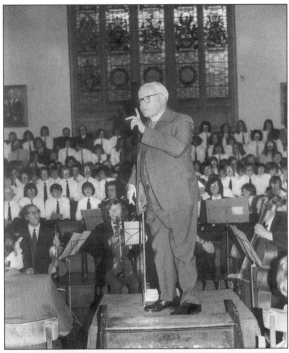

The Junior Choir, conducted by Mrs Florence Darby, performed *Holy Moses* by Old Wulfrunian Chris Hazell.

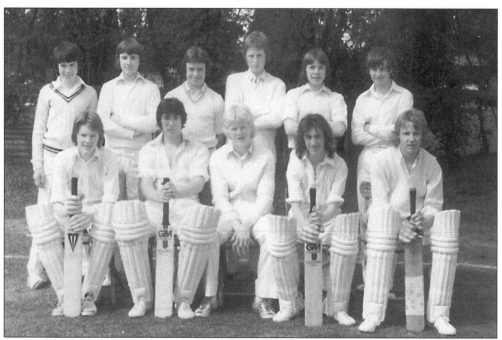

This under-15 cricket team won the Staffordshire County Championship in 1977. From left to right, back row: Mackelworth, Stephenson, Johnson, Bostock, Blount, Tomkins. Front row, Jenkin, Quance, Howard, Hemmings, Mann.

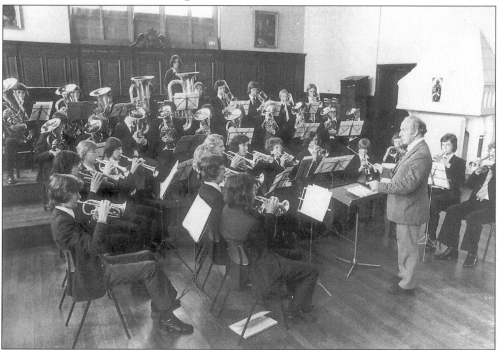

In 1976 the Brass Band under Mr Powers was chosen to play at the National School Brass Band Festival in London and gained top marks for its performance in a competition for composers.

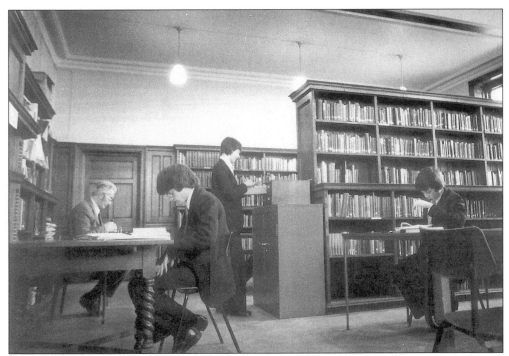

The wood-panelled library in the Merridale Building changed little during its lifetime. Mr B. Spurgin sits at the table. This became the geography room after the opening of the Jenyns library in 1981.

A lower form being taught English in a Derry Building classroom, *c.* 1977. At the front on the left is Trace Norton who holds the record for scoring the most goals (more than 60) in school matches.

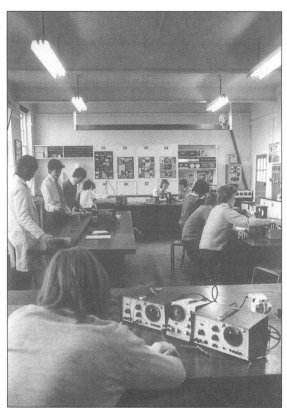

Originally the woodwork shop, this room was converted into the school's dining room during the war, when more meals had to be provided than the old boarders' dining room could handle. It became a laboratory in 1960.

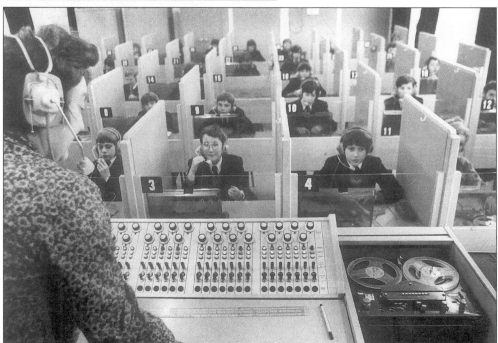

Mrs Molly Manfield teaching a class in the language laboratory, which was sited in a temporary classroom where the Design and Technology block now stands.

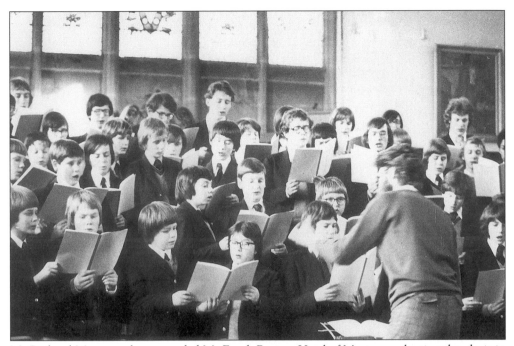

Mr Richard Mynors, who succeeded Mr Frank Rust as Head of Music, conducting the choir in Big School.

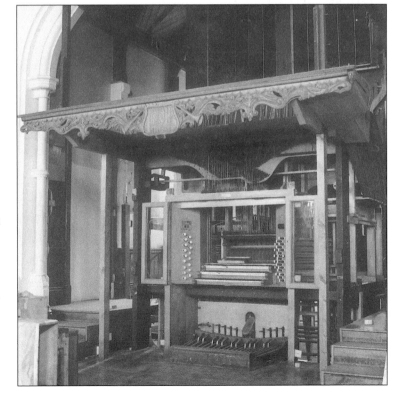

Mr Mynors rescued the organ of St Mark's church when the building was made redundant in 1978. With the support of a large team of helpers, and the advice of a professional organ restorer, it was dismantled and re-assembled in Big School.

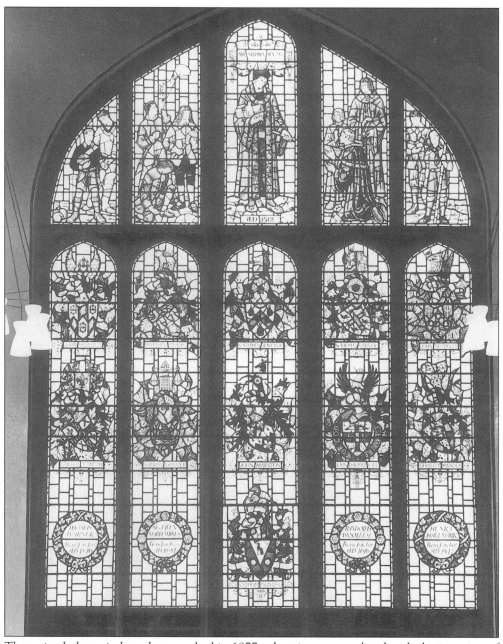

The stained-glass window photographed in 1977, when it was completed with the insertion of the last benefactor's wreath – that of Henry Hallmark.

Eight

Independence 1979-1990

The fund-raising appeal launched to save the school and bring it to independence was the most successful ever run by any school up till that time. Opened by Mr Stocks, his successor Mr Patrick Hutton saw it through to completion. After prodigious efforts on the part of all concerned, £700,000 was raised in twelve months; proof, if any was needed, of the strength of support for the school. Two-thirds of this money was used to fund assisted places for those unable to afford the fees. In addition it proved possible to pay for the building of a new laboratory and library. Although the local authority had agreed to support those already at the school until they left, long negotiations still continued to decide the division of financial responsibility. Independence, however, was secured and in September 1979 a fee-paying first-year intake joined the school.

The team of Governors, Headmaster and Bursar who achieved independence in 1979 under the Chairmanship of John Roper, who stands third from the left on the front row.

Patrick Hutton had already fought a long battle with the Inner London Education Authority over the future of St Marylebone Grammar School, of which he was Headmaster, before his appointment. A larger than life figure who led from the front, he put enormous energy into winning independence and ensuring its success.

The Stephen Jenyns library was built in 1980 with funds from the Independence Appeal.

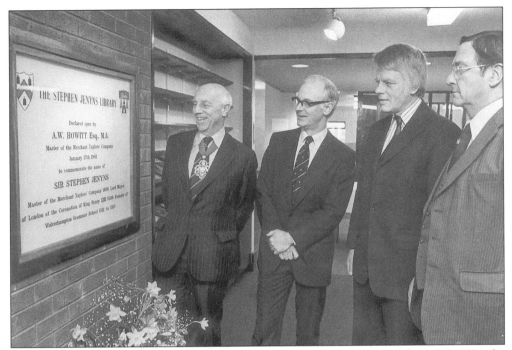

With independence, informal links with the Merchant Taylors' were strengthened. In 1981 the new library was opened by the Master of the Merchant Taylors' Company, Mr A.W. Howitt, on the left. To his right are Judge M. Ward, Chairman of Governors, Mr Hutton and Colonel R.S. Langton, President of the Independence Appeal.

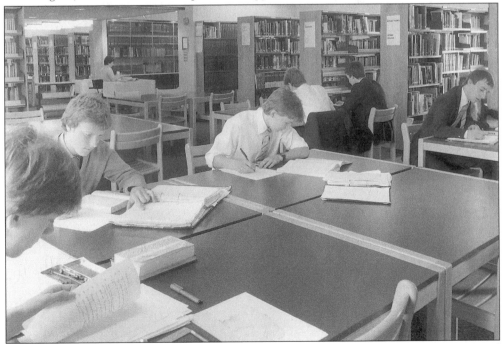

The interior of the newly opened library. Mrs Lesley Miller, at the desk, retires as Deputy Head in July 2000.

The passage between the Derry and the science building of 1908 before it was filled in with the construction of the Lister laboratory.

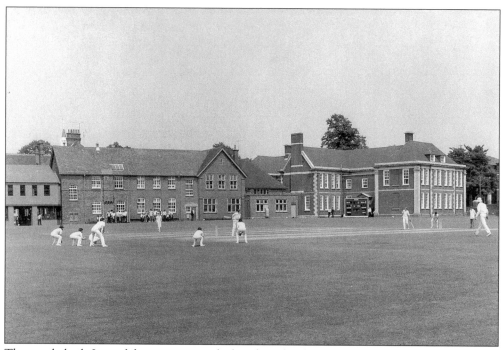

The newly built Lister laboratory, named after the school's first biology teacher, is on the left behind a cricket match of the early 1980s.

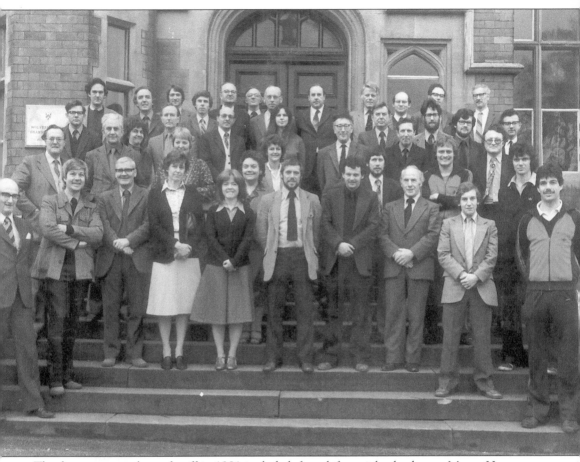

The forty-two members of staff in 1981 included, from left to right, back row: Messrs Hopton, Laceby, Shears, Unsworth, Noel, Ricketts, Manfield, Lambourne, Hutton, Storey, Brandon, Davis. Second row: Mr Brockless, Mrs Astwick, Messrs Astwick, Chugg, Seaton, Martin, Mynors, Appleton, Ditch. Third row: Messrs Evans, Spurgin, Brake, Thomas, Polack, Thorpe, Phillips. Fourth row: Mrs Manfield, Messrs Chaffey, Johnson, Pedley. Front row: Messrs Hartree, Stott, Belcher, Mrs Jefcoat, Miss Galloway, Lewis, Holden, Power, Westwood, Browning.

Mr Kevin Riley's first production, jointly with Mr Bernard Trafford, was *Joseph and the Amazing Technicolor Dreamcoat* in 1982. Simon Davis played Joseph and Stephen Skeels was Jacob.

The cast of *The Fifth Form Show They're Nuts* in rehearsal, also in 1982. They were, from left to right, back row: Humphries, Ashfield, Griffiths, Bryce, Barrett, Dibble, Jones, Whitehouse, Foreman, Buxton. Front row: Jones, Woods, Westwood, McKenzie, Martin.

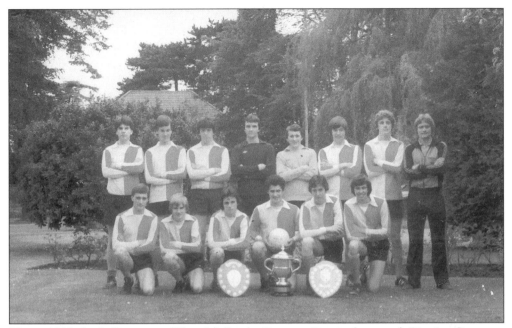

These 1982 footballers were West Midlands County, Birmingham and District Grammar Schools and Wolverhampton under-19 Champions. From left to right, back row: Jones, Rentoul, Johnson, Stephenson, Fleet, Baker, Whittingham. Front row: Burns, Gough, Evans, Whyte (captain), Morgan, Norton.

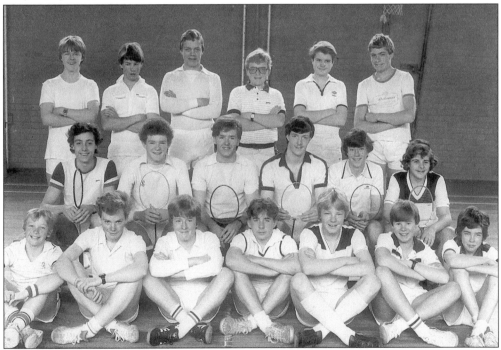

The town Badminton champions that year were, from left to right, back row: Kirk, Hester, Gibbons, Simon Skeldon, Poole, Adams. Middle row: Husselbee, Coxhead, Smith, Campbell, Duffell, Evans. Front row: Stephen Skeldon, Harris, Peters, Mills, King, Jarman, Thomas.

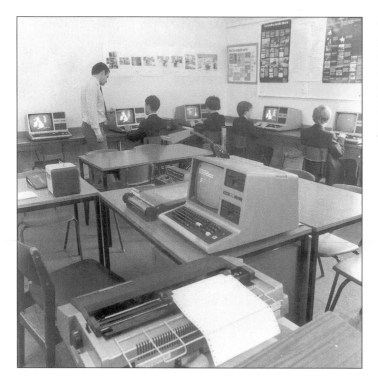

The school's first computer room was situated in the present Headmaster's office. It was equipped with Tandy TRS 80s, under the supervision of Mr James Mackenzie.

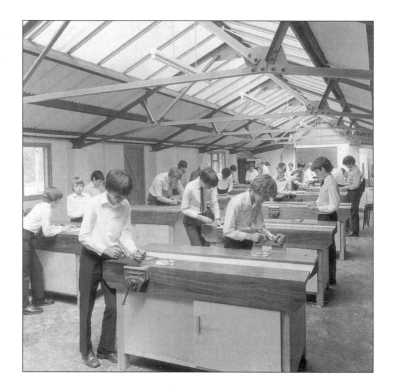

By 1982 the Rifle Range had become the woodwork shop. Mr Foreman is seen here teaching form 1S.

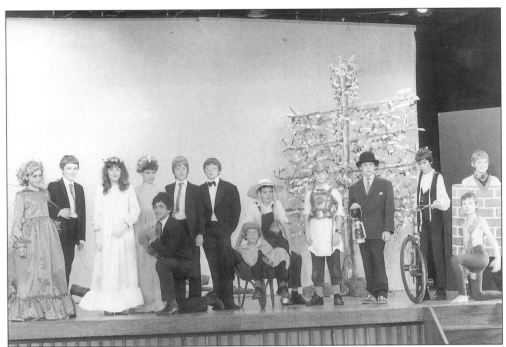

At the Junior Prizegiving in July 1983 the performers in the Mechanicals scenes of *A Midsummer Night's Dream* were Katz, Coss, Lilley, Nockels, Evans, Cutler, Das-Gupta, Sheldon, Thomas, Sinkins, Davis, Allport, Roberts and Howells.

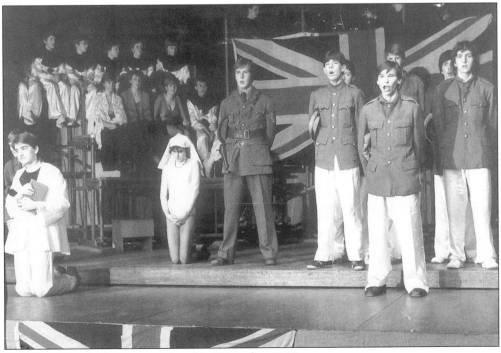

Oh What a Lovely War was produced in December 1983.

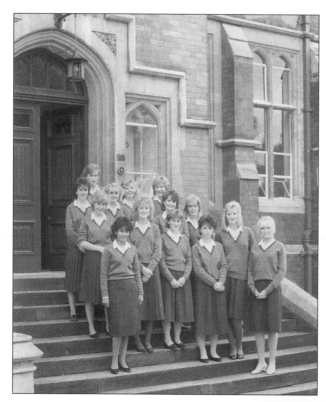

The first girls entered the Lower Sixth in 1984. They were, from left to right: Joanna Tomlin, Sarah Pooley, Georgina White, Nicola Bagby, Lila Agrawal, Lucy Wade, Cathy Purchase, Lindsay Patrick, Julie Cheetham, Philippa Budgen, Melanie Rissbrook, Elizabeth Emms, Sarah Whitmore, Louise Hobkinson.

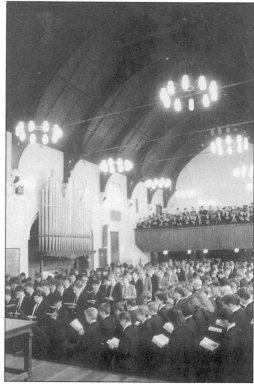

The gallery in Big School was constructed in 1985 with funds donated to the school by The Friends.

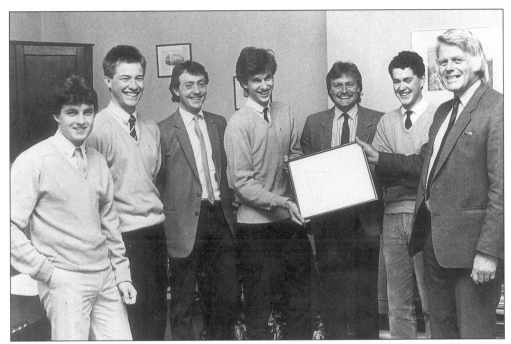

In 1985 five former pupils played in the Oxford v. Cambridge football match at Wembley. From left to right: Carlton Evans, Gary Baker, Andy Husselbee, James Rentoul, Mr Johnson, Angus Whyte and the Headmaster, who is receiving a photograph of the Cambridge team.

The third Fun Run for charity took place in 1985. The runners include Matthew Katz, Ian Garlic, Richard Hammond, Jag Judge, Simon Jarman and Stuart Green.

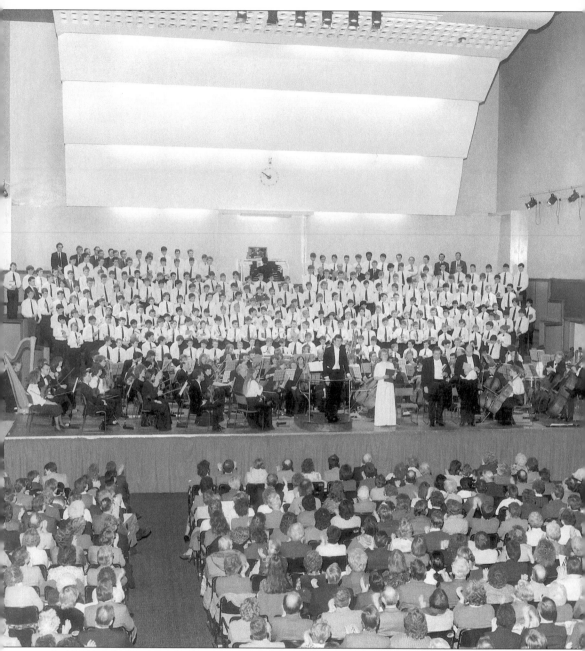

In 1987 Mr Bernard Trafford conducted the Choral Society in a performance of Elgar's *The Dream of Gerontius* in the Civic Hall. A record 287 singers took part, of whom 267 were pupils, at a time when the total number of students in the school was 617. (Courtesy of G.V. Jenkins)

In 1988 the school was shocked by the loss of Mr Neil Ricketts, Head of History from 1972, who collapsed and died in school.

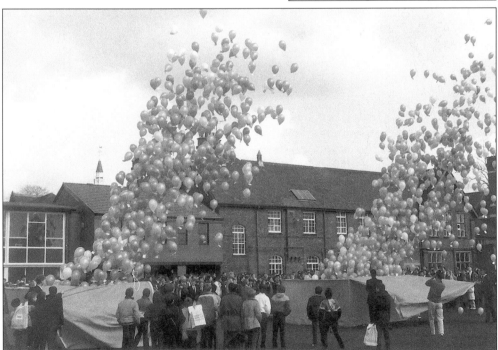

The Friends, under the Chairmanship of Mr Trevor Beeson, raised £15,000 in 1988/89, as part of the fund-raising appeal launched in 1985 for further new buildings. The Balloon Day was part of this effort.

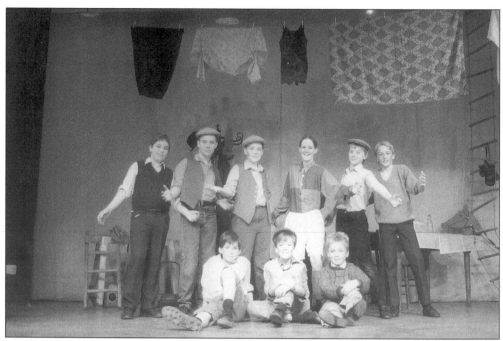

The Goalkeeper's Revenge was the junior school play in 1988, starring, from right to left, back row: Richard Williams, Ed Harper, James Bell, Peter Oakley, Paul Jenks, Paul Taylor. Front row: Tim Routledge, Andrew King, Andrew Lewis.

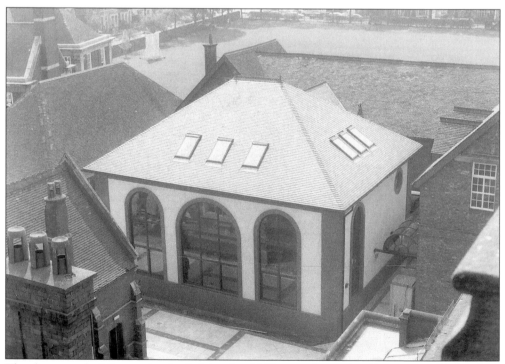

The first new building to be funded by the 1985 appeal was the Design and Technology Building, opened on 5 November 1988.

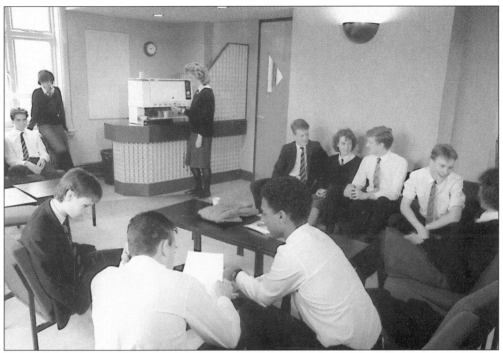

At the same time a new sixth-form area was provided in the upstairs of the area that was once the Headmaster's house. The decor was chosen by the sixth formers themselves.

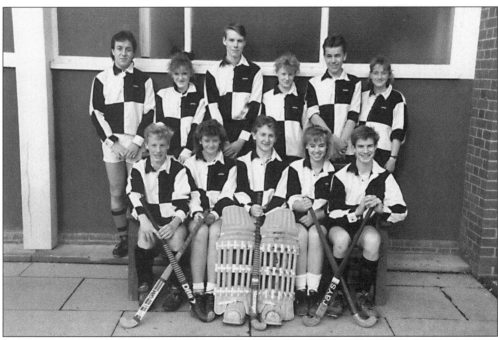

The members of the mixed hockey team of 1988/89. From left to right, back row: Josef Taheri, Rebecca Tinsley, Alan Brown, Vicky Balkwill, Hayden Jones, Helen Temperton. Front row Nic Anderson, Helen Wall, Colin Pearson, Claire Pearson, Andrew Davis.

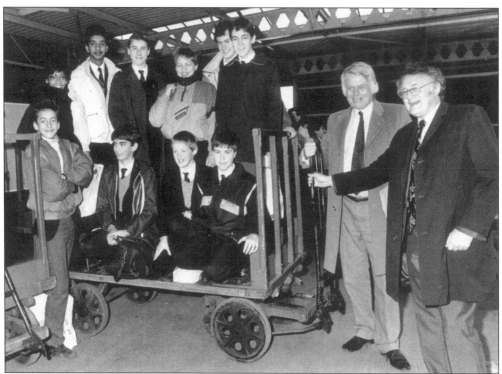

On 7 March 1989 Mr Hutton took the entire school to London, on a specially hired train, to visit the Merchant Taylors' Hall to mark the 500th anniversary of the Mastership of Sir Stephen Jenyns. The pupils on the trolley next to Messrs Hutton and Phillips are, from left to right, back row: Vijaish Sharma, Lakhveer Sahota, John Ashmore, Richard Bibby, Mark Bowles, James Burgess. Front row: Richard Chubb, Stephen Orme, Geoffrey Bache, Ian Watson.

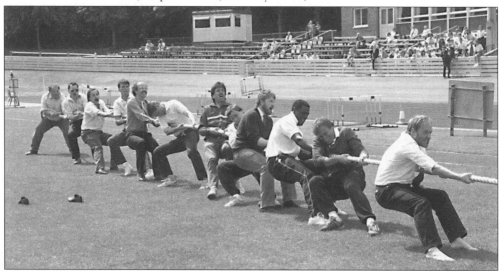

The members of the staff team in the tug-of-war at the Sports Day at Aldersley stadium that year were, from left to right: Messrs Tony Duffield, Tony Page, Malcolm Saxon, Andy Stephenson, Tony Holdford, Les Shears, Tim Browning, David Oddy, Mark Benfield, Theo King, John Johnson, Robert Kidd.

Mr Hutton and HRH the Duchess of Kent at the entrance to Big School on 26 April 1989, upon the official opening of the John Roper Room. This Middle School Common Room transformed the old cloakroom area near to Big School.

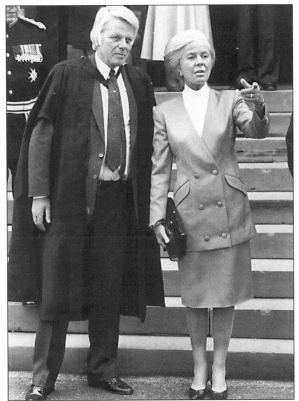

Mr Robert Brandon, history teacher and librarian for many years, shows the Duchess a display on the history of the school in the Jenyns Library. His assistant Mrs Deirdre Linton is on the left.

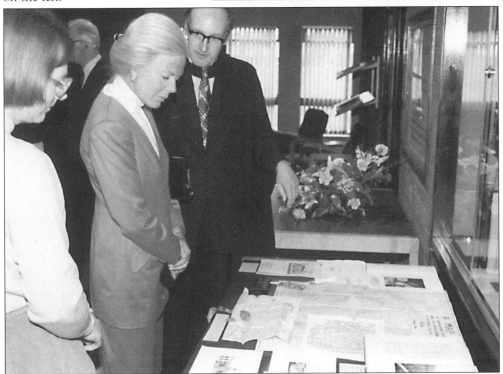

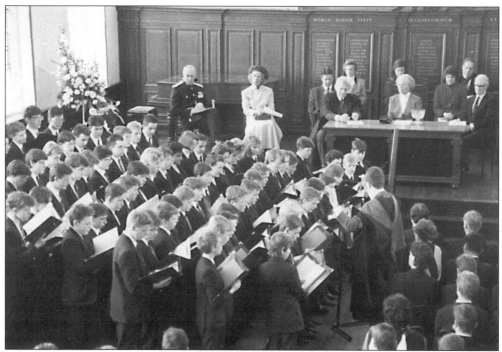

The Duchess sits between Mr Hutton and Judge Ward, while Mr Bernard Trafford, who was appointed Headmaster upon the retirement of Mr Hutton in July 1990, conducts the choir.

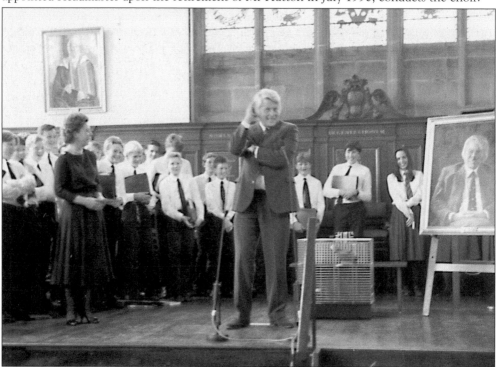

Mr Hutton was presented with a parrot at a farewell presentation. The portrait on the right was painted by Mr Michael Astwick, Head of Art from 1978 to 1991.

Nine
Co-education
1990-2000

Upon his appointment Bernard Trafford was the youngest Headmaster since Warren Derry. Recognizing that the introduction of co-education throughout the school was a priority, he approached the project with enthusiasm. As the addition of girls into the lower forms would inevitably lead to the expansion of the school, it followed that a programme of building was necessary. A new classroom block, built in the old Derry courtyard, was opened in 1992 to coincide with the arrival of the first cohort of girls joining the first form. Since the school's sports facilities had long since become inadequate, a new Sports Hall was built in 1993 designed to provide a far wider choice of sports activities. This was followed by the construction of a large Sixth Form Centre in 1995. The twentieth-century school reached its greatest size in September 1996 with a total of 794 pupils, of whom 528 were boys and 266 were girls.

In 1990 the choir that toured Italy was still fundamentally a boys' choir with the addition of a few sixth-form girls. This was an accurate reflection of the school as a whole.

Bernard Trafford came to the school as Head of Music in 1981 and was also Head of Sixth Form before his appointment as Headmaster. An ardent believer in student democracy, for his study of which he was awarded a PhD in 1996, he founded the Student Council.

A much respected Deputy Headmaster, geography teacher and cricket umpire, Mr David Lambourne will retire in July 2000 after twenty-six years' service to the school.

A group of third formers leaving the John Roper entrance between lessons in 1991. The bell brought from St John's Street can be seen above the door.

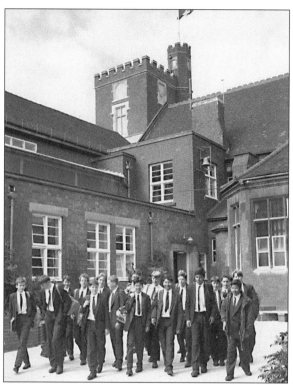

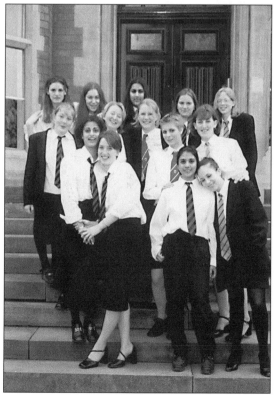

These pioneering girls of the 1992 first form left in 1999. From left to right, back row: Louisa Pearson, Rebecca Groves, Ranvir Dhoot, Caroline Lee, Elizabeth Linton. Middle row: Frances Taylor, Poonam Thaker, Amy France, Mari Gough, Claire Kenward, Leila Toosi. Front row: Claire Wooldridge, Fatema Hirani, Therese Ward.

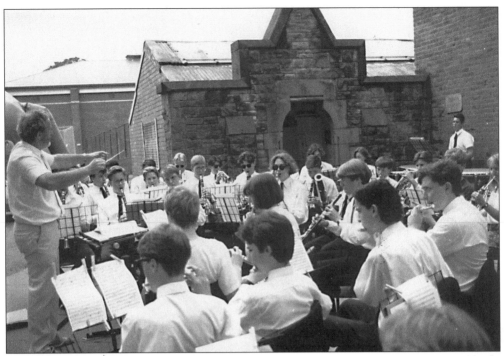

Mr Stuart McIntosh founded the Big Band, here playing at the 1993 Garden Party. The old rifle range can be seen in the background.

In 1994 Dr John Darby retired as Head of Science after thirty-eight years service as a chemistry teacher.

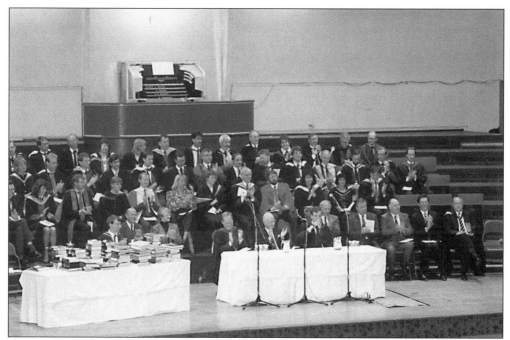

The staff and governors applaud the Headmaster's speech at Prize-giving, held at the Civic Hall in 1993. The guest speaker, sitting to the left of the Chairman of Governors, Judge Ward, was Mr Kevin Riley, former Head of English who had left to become Headmaster of Bristol Cathedral School.

Mr Keith Brockless became the longest serving member of staff upon the retirement of Dr Darby. He joined the Classics Department in 1960 but later retrained as a Modern Linguist. He retires in July 2000.

With Mr Graham Lewis, Head of Sixth Form and his Deputy, Mrs Robin Roberts, are the senior prefects of 1994/95, from left to right: Jonathan Downer, Sathnam Sanghera, Jane Sims, James Ridout, Anna Hocking, David Sims, Ben Styles.

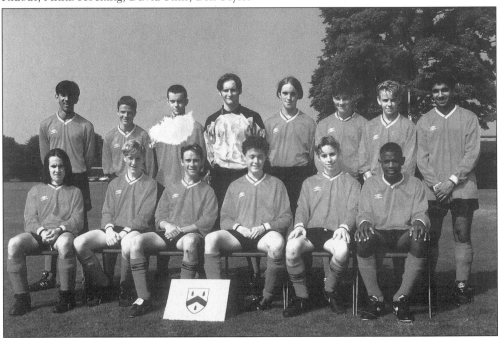

The footballers who toured the United States of America in 1995 were, from left to right, back row: Khosla, Walford, Bytheway, Wrynne, Mills, Wasden, Wooldridge, Chadha. Front row, Holmes, Hobbs, Austin, Smyth, Wilkes, Robinson.

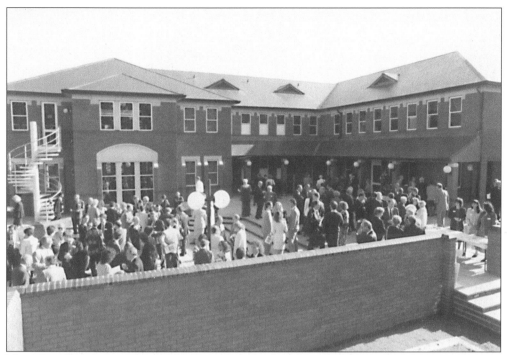

The official opening of the Sixth Form Centre took place in 1995.

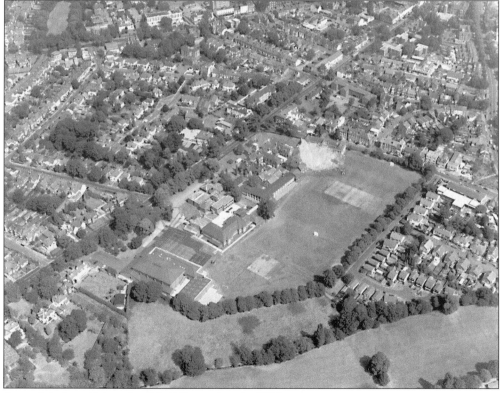

An aerial view of the school buildings taken in 1995.

The Staff XI in 1996. From left to right, back row: Messrs Nick Munson, Tony Page, Peter Hills, Tim Browning, Andrew Carey, Nigel Crust. Front row: Ian Barnwell, Mark Benfield, John Hegan, Nic Anderson, John Johnson.

Miss Connie Brough was Headmaster's Secretary for twenty-five years. She served four successive Headmasters, three of whom attended her retirement party in 1997. (Courtesy of G.V. Jenkins)

The Big Band, with Mr Andy
Proverbs, featured in the *Express and
Star* after joining Roy Wood's Army
for a concert in aid of the *Sharing the
Vision* Appeal on 17 December 1998.
Nick Gray, bottom right, is the
current Head Boy.

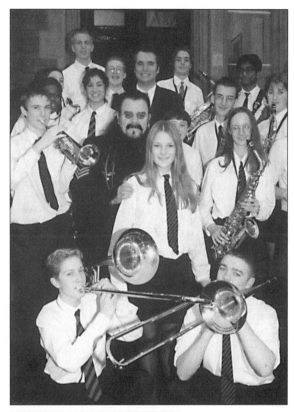

The Student
Council, meeting
in the Sixth
Form Centre
Library in 1999
with the
Headmaster. Mr
Joe McKee is
seated on the
spiral staircase.

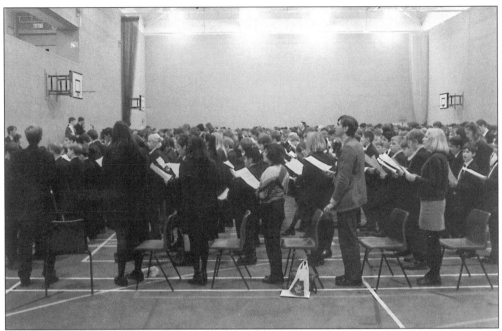

In 1999 the school met in the Sports Hall for the end of term assembly. There were too many pupils to fit into Big School by this time. The school is singing *Jerusalem*.

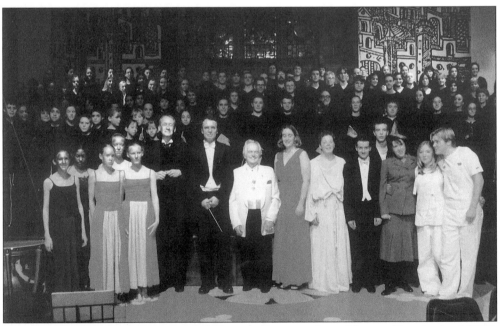

The Choral and Drama Societies staged *Carmina Burana* and two Mystery Plays in April 2000. Those on the front row are, from left to right: Hannah Burd, Poppy Flint, Holly Johnson, Laura Guest, Katie Young, Mr Roy Batters, Mr Andy Proverbs, Mr Norman Tattersall, Miss Sarah Louise Best, Simon Hacking, Jonathan Wood, Tom Johnson, Grace Gelder, Gemma Griffiths, Nick Grosvenor.